IMAGES
of America

DESERT HOT SPRINGS

ON THE COVER: THE B-BAR-H RANCH. This 1947 picture includes the B-Bar-H Ranch owners and family members along with movie star Peter Lorre, seated on the horse on the right. Others are, from left to right, an unidentified ranch wrangler in the wagon; owner Marie Kasler; grandson Richard Roger; Marjorie Roger, with Steve in her lap; and owner Jay Kasler, on a horse. Manager Louise Gillis is also in the photograph; however, she is out of view on the cover. (Courtesy of the Desert Hot Springs Historical Society.)

IMAGES
of America

DESERT HOT SPRINGS

Desert Hot Springs Historical Society

ARCADIA
PUBLISHING

Published by Arcadia Publishing
Charleston, South Carolina

Printed in the United States of America

Library of Congress Control Number: 2014932392

For all general information, please contact Arcadia Publishing:
Telephone 843-853-2070
Fax 843-853-0044
E-mail sales@arcadiapublishing.com
For customer service and orders:
Toll-Free 1-888-313-2665

Visit us on the Internet at www.arcadiapublishing.com

The Desert Hot Springs Historical Society is dedicated to preserving, acquiring, and displaying the local history of Desert Hot Springs. Please visit dhshistoricalsociety.com.

CONTENTS

ACKNOWLEDGMENTS

The Desert Hot Springs Historical Society is happy to be able to present the history of Desert Hot Springs, a desert town with an intriguing story. For many years, our archives were in a storage facility and unavailable for study. Two years ago, the historical society was able to move them to where they could be sorted and filed for future use. Five members of the society spent hundreds of hours working with the archival material to make this book a reality. In alphabetical order, they are: Larry Buchanan, Ron Gilbert, Muffi Mendelson, Audrey Moe, and Marge Snell. Special thanks go to Muffi Mendelson, who spearheaded and coordinated the project, and to Ron Gilbert, who did all of the scanning and digitizing of the pictures. The chapter on Cabot Yerxa was completed by two members of Cabot's Pueblo Museum, Richard Brown and Judy Gigante, and we thank them for their input. Others who contributed in various ways are Jeff Bowman, Ernesto Fortin, John Furbee, and the Desert Hot Springs Chamber of Commerce. Our sincerest apologies go to anyone we have inadvertently left out. It was the combined efforts of dedicated historical society members that made this book possible. Space determined what was included and what had to be left out. Through it all, we have tried to be as accurate as possible in presenting a historical picture of how a town grew from the desert sands into a spa-oriented community, attracting visitors from around the world. Unless otherwise noted, all images appear courtesy of the Desert Springs Historical Society.

INTRODUCTION

"It's the water" would be an appropriate motto for the city of Desert Hot Springs. Very few other places in the world can boast of naturally occurring hot and cold mineral water of the purest and most beneficial quality. It was the water accumulating in natural seeps scattered over a barren desert landscape that attracted Native Americans to camp in the area during the winter months when they left their canyon and mountain homes for the warmth of the desert. Hundreds of years later, it is still the water that attracts residents and visitors to Desert Hot Springs.

In 1900, there were less than 100 non-Indian settlers in the Coachella Valley, and almost no one had made a home in the northwest quarter where Desert Hot Springs is located. The West was still an exotic and unknown land of mountains, deserts, and canyons. The desert, where water was scarce, cactus and scrubby plants dominated, and rain came seldom, had not attracted pioneers willing to brave the elements and unknown dangers to settle and carve out a new life. The Homestead Act of 1862 enabled adventurous, hardy souls to claim land where it was still available. The desert was free for the taking as homesteaders began to trickle in beginning around 1903.

Three main water sources over five miles apart provided the water needs for these early people. Getting water every day was one of their main tasks for survival. Willow Hole to the east and Seven Palms and Two Bunch Palms to the west provided water from seeps in the sand. Willow Hole, used by wildlife and Native Americans for countless years, is protected today by the Bureau of Land Management and is accessible to wildlife only. Two Bunch Palms developed into an elite health resort, and Seven Palms remains a small enclave supporting a grove of native palms, encouraged by water found close to the surface.

Cabot Yerxa, one of the early homesteaders, arrived in 1913 and is credited with the discovery of the exceptional hot and cold water located in the area. Cabot built Eagle's Nest, his first home, which was a rock house dug into the side of a hill. He named the place Miracle Hill for the hot and cold water found there. As Cabot developed ways to thrive in the desert, he built a trading post that served other homesteaders and attracted prominent customers who were visiting the desert.

Cabot, a descendant of Boston's Henry Cabot Lodge family on his mother's side, was an adventurer with an intriguing story of experiences in Cuba, Alaska, and Europe before he became a permanent resident of the Desert Hot Springs area. He was also a Renaissance man whose cosmopolitan attitude attracted so many prominent people to his rustic home on Miracle Hill. Jack Krindler, owner of the famous Twenty-one Club in New York City; Louis Sobol, writer for the *New York Journal*; and movie stars Gary Cooper, Cary Grant, Joan Crawford, and Marlene Dietrich, along with many others, are noted in Cabot's journals. Cabot, an intriguing adventurer, shared his genius and left a legacy after his death. Cabot's Pueblo Museum, a structure he spent a large part of his life building by hand, is in the National Register of Historic Places.

It was also Cabot who, during the 1930s, introduced a developer to the finest natural hot water spas anywhere in the world. L.W. Coffee of Los Angeles began laying out a street grid for a future city that he named Desert Hot Springs. To promote the water, Coffee built a bathhouse to accommodate visitors, and it opened in 1941. Over 2,000 people attended the opening, while the city still had only about 20 full-time residents. Celebrities known to be regular bathhouse visitors included Gene Autry, Al Jolson, and William Holden.

Around the same time, an analysis of the hot water revealed a therapeutic blend of natural elements considered to have healing properties, which encouraged Dr. Robert Bingham to begin treating children crippled by polio during the epidemic of the 1940s. His treatments were so successful that they led to the establishment of Angel View Crippled Children's Hospital, which continues today with an expanded program to treat adults with disabilities as well as children.

Clark Gable attended the dedication of one of the hospital wings, arriving in a helicopter. Also in attendance were Sonja Henie, the ice-skater, and other dignitaries.

Perhaps a more appropriate name for this water-inspired community would be "Spa City," since the main economy of the town is based on its spas. The majority are small owner-operated spas with specialized services. Two Bunch Palms Spa and Resort caters to the elite and provides a hideaway for celebrities and prominent people. Even though the resort does not reveal the names of its guests, some stories leak, which is how we know the Rolling Stones took over the entire resort in the 1980s.

Another important period for the town was the dude ranch era in the 1940s and 1950s, when the B-Bar-H Ranch was in full swing with a celebrity clientele from Hollywood, New York, Chicago, and around the country. Mary Pickford, John Barrymore, Joan Crawford, Rita Hayworth, Ray Miland, and Tyrone Powell are but a few of the stars who frequented the ranch. Earlier in the 1930s, movies were filmed on Warner Baxter's Circle B Ranch, and up until World War II, the biggest names in the movie industry vacationed there, riding horses and lolling around the swimming pool.

Some ranches were private, like Singing Tree, owned by Paul Gregory and Janet Gaynor, the first woman to receive an Academy Award. Paul Gregory is often remembered as the producer of *Night of the Hunter*, starring Robert Mitchum and Shelly Winters. Of the many prominent friends who visited Singing Tree, most people do not know that Marilyn Monroe spent a week there shortly before her death.

In 2014, with a population of approximately 28,000, Desert Hot Springs is one of the nine cities in California's Coachella Valley. Located east of Los Angeles and nestled between two mountain ranges, the desert landscape and climate are still appealing to snowbirds, who often decide to build permanent homes. The mild winters provide a playground for visitors and business opportunities for full-time residents. Desert Hot Springs, with its exceptional water and varied spa opportunities, provides a specific niche for vacationers. Its rich and varied history is sometimes forgotten in the frantic pace of daily activities, but few small cities can claim the exciting events and people that built the town.

In this book, we have attempted to highlight some of the important milestones and people who worked to build a city based on exceptional water from desert aquifers. It is our goal to preserve for future generations the history of the events and people that built this city.

CHRONOLOGY
DESERT HOT SPRINGS, CALIFORNIA

1858 A government survey of the area around Desert Hot Springs is conducted.

1876 The Southern Pacific Railroad establishes a stop at Garnett.

1908 Jack Riley becomes the first homesteader to establish a claim in Desert Hot Springs.

1912 Schoolteacher Ethel Rouse establishes the first school in a dugout near Seven Palms.

1913 Cabot Yerxa arrives, along with his friend Bob Carr, and Cabot establishes a 160-acre homestead on Miracle Hill.

1914 Cabot builds Eagle's Nest, a stone cabin, and discovers both hot and cold water in Miracle Hill.

1927 Lucien Hubbard and Charles Bender establish the B-Bar-H Ranch in the Bubbling Wells area.

1932 L.W. Coffee meets Cabot and learns of Desert Hot Springs' hot mineral water.

1933 Coffee and Bill Anderson survey the area for a land trust and build an adobe office.

1933 Viola Dinsmore erects a tent at Eighth Street and Palm Drive, which eventually becomes her home and the Blue Heaven Rancho.

1934 William Tarbutton drills the hot water "Discovery Well" for Coffee.

1937 Cabot returns to Desert Hot Springs from Moorpark, California, and opens his trading post.

1939 Aubrey Wardman buys 160 acres and asks Coffee to develop cabin sites.

1939 Cabot begins work on his old Indian pueblo and continues until his death in 1965.

1940 The Bureau of Land Management opens Two Bunch Palms for development.

1941 Coffee builds his first bathhouse. Over 2,000 people attend the grand opening.

1941 The Dodd family opens the Idle Hour Café at Palm Drive and Pierson Boulevard.

1942 The first issue of the *Desert Sentinel* is published.

1944 The first post office opens at Palm Drive and Pierson Boulevard.

1945 Two stores, Desert Market and Les Morgan's Grocery, are established.

1946 The first elementary school is established on Second Street.

1947 Architect John Lautner builds his first commission in the desert, a mid-century Modern-style gem, the Desert Hot Spring Motel.

1948 A movie theater and malt shop open.

1953 The chamber of commerce starts the "Fiesta of Hot Waters."

1953 Desert Hot Springs County Water District is established.

1955 The Angel View Crippled Children's Foundation clinic opens on Pierson Boulevard.

1956 Angel View Rehabilitation Hospital breaks ground at Desert View and Miracle Hill Roads.

1963 Desert Hot Springs is incorporated as a city.

1968 The State of California declares Cabot's Indian pueblo a Historical Point of Interest.

1969 Cole Eyraud becomes caretaker for Cabot's Indian pueblo, continuing until his death in 1996.

1992 A 6.1 earthquake hits Desert Hot Springs, with light damage due to the quake's depth.

1998 The city receives title to Cabot's Indian Pueblo and establishes a commission to develop the site.

2012 Cabot's Pueblo Museum is placed in the National Register of Historic Places.

2014 Desert Hot Springs' population is 27,902.

One

"It's the Water"

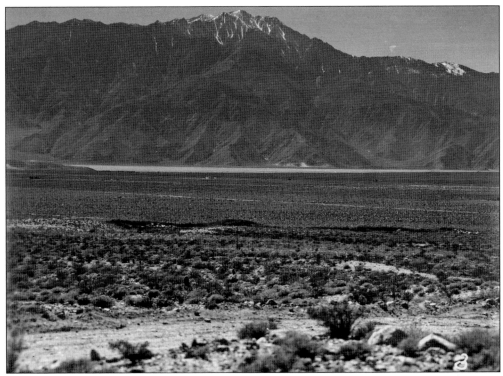

UNDATED PHOTOGRAPH. Before the development of the city of Desert Hot Springs in the 1930s and 1940s, the region was a treeless plain on the northern edge of the Colorado Desert surrounded by towering mountains and deep canyons. Native Americans visited the area but did not settle here, opting for more sheltered parts of the Coachella Valley.

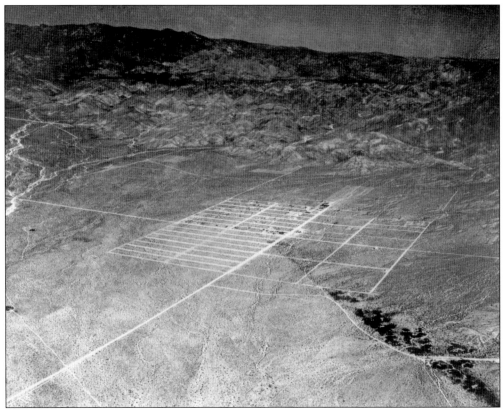

AERIAL VIEW, 1937. This view of the townsite of Desert Hot Springs clearly shows the Mission Creek fault bisecting what would become the village of Desert Hot Springs in a few short years. At top left is the Mission Creek drainage area, with the San Bernardino Mountains in the background. The San Bernardino Mountains supply the flow of meltwater that feeds the aquifers.

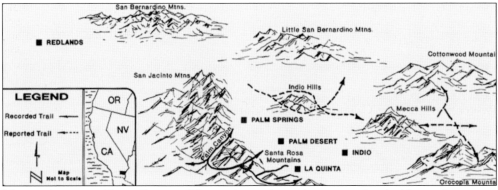

NATIVE AMERICAN TRADE ROUTES. This trail map shows the routes taken by Native Americans in the upper Coachella Valley. Willow Hole, Two Bunch Palms, and Seven Palms were used as watering holes, and there was a small village at Seven Palms, as noted in an 1858 census.

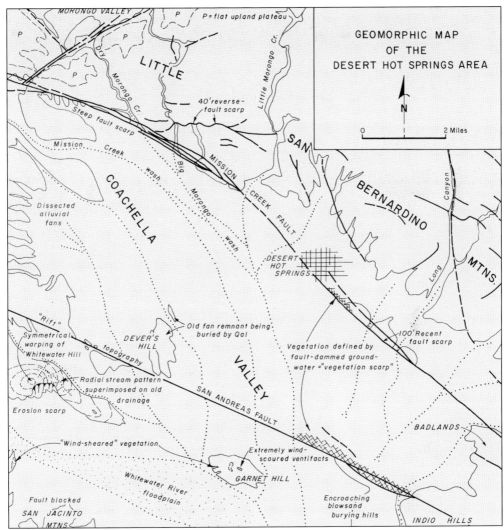

FAULT MAP OF DESERT HOT SPRINGS AREA. This map shows how the Mission Creek Fault bisects the city. The Mission Springs Fault branches from the main (San Andreas) Banning Fault in Indio Hills, and the smaller Miracle Hill Fault branches to the north of the Mission Creek southeast of the present-day Desert Hot Springs. The Banning Fault runs through Willow Hole, an important drain for flash floodwater from the Long Canyon, Desert Crest, and Sky Valley areas. The Mission Creek Fault provides a vital dam for the hot water pools that form the hot water aquifer in the spa zone. The Banning Fault provides the dam for the colder drinking water that is generally found at greater depths. (Courtesy of *Geology of the Desert Hot Springs Upper Coachella Valley*, by Richard Proctor [San Francisco: California Division of Mines and Geography, 1968].)

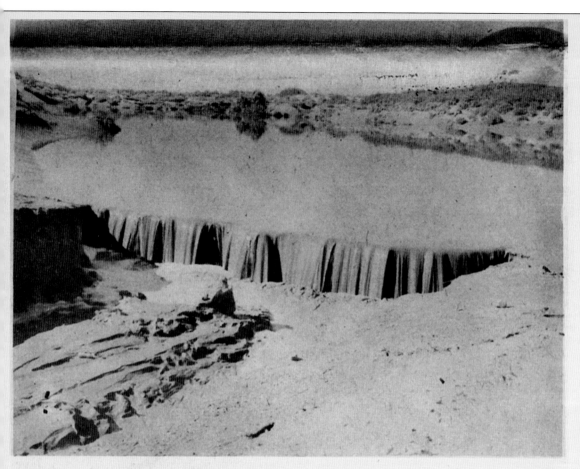

NOT NIAGRA FALLS — Area on Mountain View Aenue north of Varner Road, often called Willow Hole, was where much of the floodwaters wound up. In this spot the weight of the water was such that it broke into an underground cavern and drained into it apparently. Photographer was not too interested in venturing close to the hole to find out however. Photo was taken Oct. 24. (Desert Sentinel photo)

WILLOW HOLE FLOODING NEWSPAPER PHOTOGRAPH. Willow Hole acts as a drain for the area east of Desert Hot Springs during infrequent flash floods. This flash flood of October 24, 1974, produced a spectacular waterfall feeding the aquifers of the Mission Creek and Miracle Hill Faults.

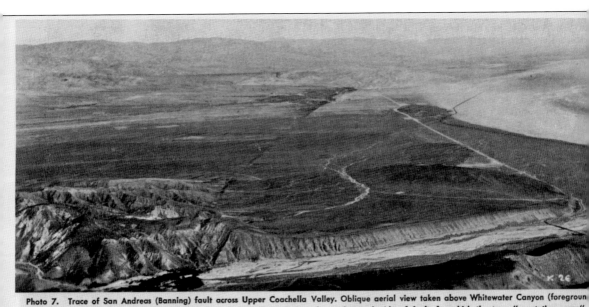

Photo 7. Trace of San Andreas (Banning) fault across Upper Coachella Valley. Oblique aerial view taken above Whitewater Canyon (foreground toward east. Fault-dammed ground water has caused vegetation to grow only on the north side of fault, for which the term "vegetation scarp" proposed, as seen in Whitewater Canyon and in Seven Palms Valley west of Indio Hills (center of photo). Note also vegetation on fault trace Mission Creek fault at center-left of photo.

Aerial View of Faults. The trace of the San Andreas (Banning) Fault is shown in the center. The Mission Creek Fault is in the distance. Note the vegetation on the north side of both faults where groundwater is dammed.

Table 2. Water Well Data.

(Depth and temperature readings on upper aquifer)

Name of well	Location	Date drilled	Depth to water (feet)	Temperature °F.	Ground elevation (feet)
Discovery	sec. 30	1934	154	146	1200
Original Bath House	"	pre-1940	170	118	1210
Coffee Bath House Wells (4)	"	1940–1954	157	108–116	1195
Chandler	"	pre-1950	160	125	1210
Blue Haven	"	pre-1950	140	130	1200
Realty Co. of America Demonstration	"	1952	212	120	1260
Dorsk	"	1957	149	120	1240
Kibby	"	1951	135	77	1160
Neone	"	1946	127	104	1180
#1 (Desert Hot Springs Co. Water District)	"	1941	92	88	1096
#6 (Desert Hot Springs Co. Water District)	"	1955	90	88	1098
#7 (Cree; Desert Hot Springs Co. Water District)	sec. 25	1950 & 1957	161	82	1195
Herbold	"	1947	132	82	1150
Woods	sec. 20	1939	340[1]	80	1450
#2 (Miracle)	sec. 32	1948	143	145	1190
#8	"	1952?	76	142	1135
#11	"	1956	40	146	1065
#12	"	1952?	150	134	1220
#13	"	1952?	165	153	1240
#15 (Yerxa #1)	"	1940	90	122	1115
Davis	"	1949	128	102	1125
#17 (Templeman)	"	1955	95	156	1135
#18 (Angel View Crippled Childrens Foundation, Inc.)	"	1955	138	136	1170
#19 (Schwartz)	"	1955	54	150	1070
#21 (Yerxa #3)	"	1940	40	140[2]	1065
#22 (Sullivan)	"	1956	161[3]	166	1010
McCollough	sec. 31	1940 & 1954	220	88	990
#3 (Desert Hot Springs Co. Water District)	"	1940	48	95	1060
#5 (Desert Hot Springs Co. Water District)	"	1948	29[4]	95	1030
#9 (Highland's Desert Hot Springs)	sec. 33	1955	165	120	1215
#10 (Simone and Babin)	"	1954	136	112	1185
Hubbard #1	sec. 5	1946	16	108	960
Hubbard #2 (Bubbling Wells)	"	1947	23	108	990
McDonald	sec. 6	1957	190	82	960
Reeves	sec. 4	1949	76	95	1070
Bannon, et al.	"	1957	182	90	1115
Perdue	sec. 9	1947	168	80	940
Erwin and Assoc.	sec. 3	1954	225	98	1150
Terra Vista Corporation	"	1954	164	94	1060
Johnson #2	"	1955	147	106	1045
Holmes	sec. 10	1951	80	165	980
Lucky 7	"	1950	83	184[5]	990
Young	"	1951	75	118	945
Guptill	"	1956	117	106	1030
Langois	sec. 11	1953	110	175	1010
Johnson #1	"	1951	105	175	1000
Moody	"	1956	170	150	1090
Tarbutton	"	1955	112	96[6]	1025
Kiel	sec. 14	1951	265	103	990
Simone and Babin	"	1953	148	130	1040
Paddock	"	1956	220	134	1090

[1] Water in sheared or jointed gneiss. Total depth of well is 487 feet.
[2] Temperature is 176° F. at 200-foot depth.
[3] Middle water strata; spring at surface nearby is the only surface water occurrence in the area.
[4] Total depth is 807 feet, deepest well in area.
[5] Hottest water well in region. Middle aquifer at 157–167 feet yields 188° F.; lower aquifer at 188–218 feet yields 200° F.; total depth of well is 331 feet but no water beyond 218 feet.
[6] Temperature at 210-foot depth is 125° F.

WELL DRILLING TABLE. This table shows the history of water well drillings between 1934 and 1957, showing the temperature and depth of each well. Note that Desert Hot Springs' award-winning drinking water is found at a depth of around 1,000 feet, generally to the south and west of the Mission Creek Fault and to the north and east of the Banning Fault.

1953 Aerial View. This 1953 aerial view of Desert Hot Springs shows the Mission Creek Fault and the deep canyons where flash flooding occurs. Long Canyon is clearly shown to the right.

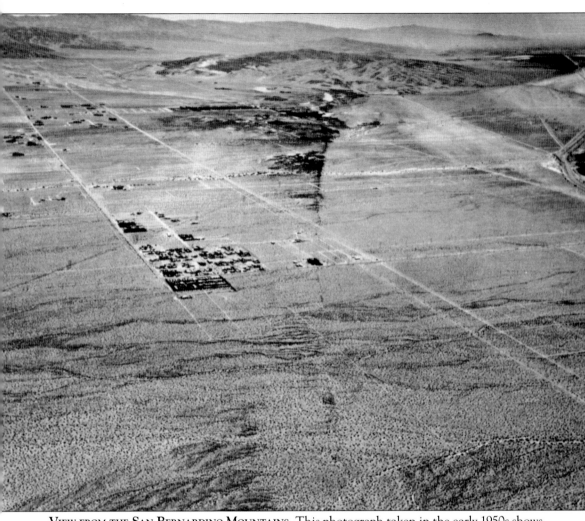

VIEW FROM THE SAN BERNARDINO MOUNTAINS. This photograph taken in the early 1950s shows the vegetation growing on the north side of the San Andreas (Banning) Fault. In the background are the Indio hills, and the foreground is the town of North Palm Springs. The sparsely populated area to the upper left is Desert Hot Springs.

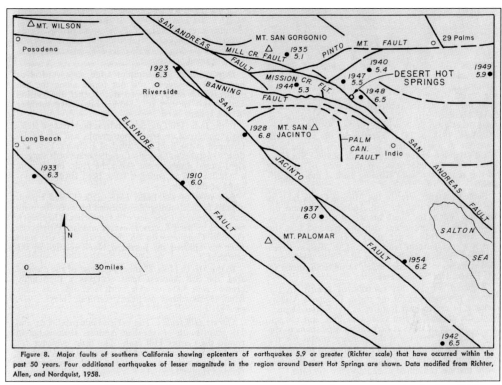

Figure 8. Major faults of southern California showing epicenters of earthquakes 5.9 or greater (Richter scale) that have occurred within the past 50 years. Four additional earthquakes of lesser magnitude in the region around Desert Hot Springs are shown. Data modified from Richter, Allen, and Nordquist, 1958.

EARTHQUAKE MAP. Desert Hot Springs has experienced at least four major quakes before 1959 and one since but has sustained only minor damage because of the depth of the quakes in the area.

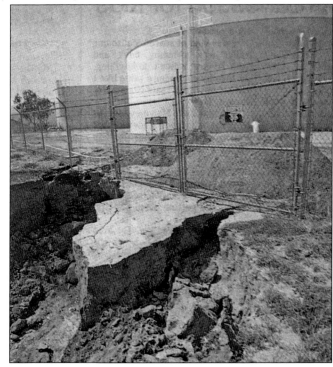

EARTHQUAKE PHOTOGRAPH.
A 6.1 earthquake struck
Desert Hot Springs on
August 23, 1992, causing
minor damage. This
30,000-gallon water spill
was from a ruptured pipe
flowing from a 450,000-gallon
reservoir belonging to the
Mission Springs Water
District near Two Bunch
Palms. This was the greatest
damage caused by the quake.

THE COLORADO RIVER AQUEDUCT. The aqueduct was an engineering marvel. It provided drinking water for the Los Angeles area and helped replenish the Coachella Valley aquifer at Whitewater. Also, it replenishes the Mission Creek aquifer at Worsley Road. In addition to drilling large tunnels through 90 miles of mountains, Kaiser engineers had to devise a way to make water run uphill (roughly 1,000 feet) at Desert Center.

TEMPORARY CONSTRUCTION CAMPS. During the Great Depression, 10,000 men worked on the aqueduct bringing Colorado River water to the fast-growing Los Angeles Basin. Much of this work was done on the northern edge of Desert Hot Springs. Nearby, Berdoo Camp was a temporary city that included a field hospital, housing, and other amenities.

WELL DIGGING. Well digging continues to be a big business in Desert Hot Springs. This photograph is from a well being drilled at Bubbling Wells Ranch. William Tarbutton drilled nearly all of the wells in and around Desert Hot Springs, beginning with the Discovery Well in 1932.

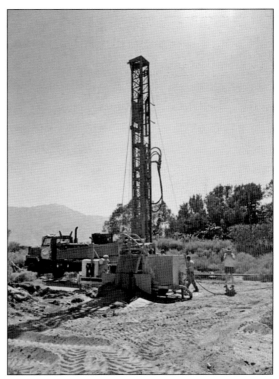

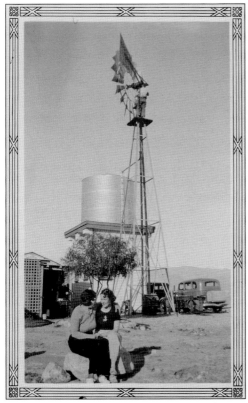

EARLY WINDMILL. Wind power has been used to help bring water to the surface. This location was on Jack Riley's homestead near Mountain View and Dillon Roads.

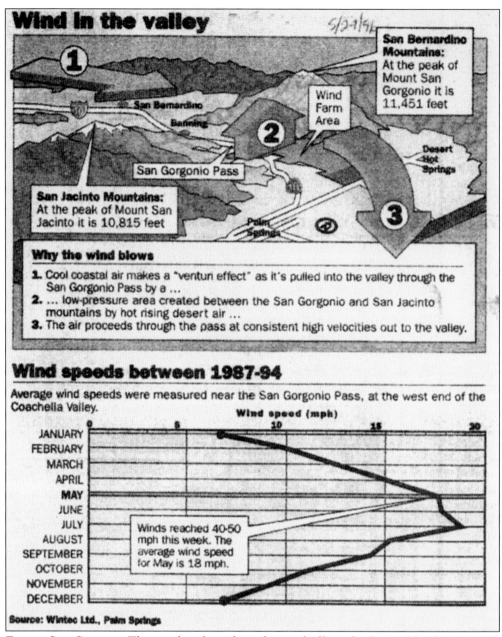

Wind in the valley

5/27/96

San Bernardino Mountains:
At the peak of Mount San Gorgonio it is 11,451 feet

(1)

San Bernardino

Banning

Wind Farm Area

(2)

San Gorgonio Pass

Desert Hot Springs

San Jacinto Mountains:
At the peak of Mount San Jacinto it is 10,815 feet

Palm Springs

(2)

(3)

Why the wind blows

1. Cool coastal air makes a "venturi effect" as it's pulled into the valley through the San Gorgonio Pass by a ...
2. ... low-pressure area created between the San Gorgonio and San Jacinto mountains by hot rising desert air ...
3. The air proceeds through the pass at consistent high velocities out to the valley.

Wind speeds between 1987-94

Average wind speeds were measured near the San Gorgonio Pass, at the west end of the Coachella Valley.

Wind speed (mph)

| | 0 | 5 | 10 | 15 | 20 |

JANUARY
FEBRUARY
MARCH
APRIL
MAY
JUNE
JULY
AUGUST
SEPTEMBER
OCTOBER
NOVEMBER
DECEMBER

Winds reached 40-50 mph this week. The average wind speed for May is 18 mph.

Source: Wintec Ltd., Palm Springs

DESERT SUN GRAPHIC. This graphic shows how the wind affects the Desert Hot Springs area, with the highest winds occurring in the summer months. The summer winds and higher elevations help Desert Hot Springs to be roughly five to seven degrees cooler than the rest of the Coachella Valley.

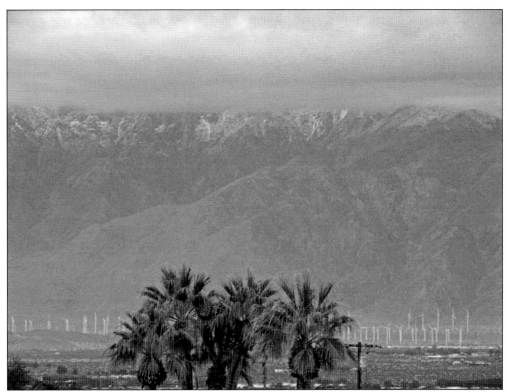

WIND FARMS. The windmill farm in the San Gorgonio Pass and to the west of Desert Hot Springs provides electricity to the Southern California grid. Along with the growing use of solar power, the wind power makes the Desert Hot Springs area a leader in renewable energy.

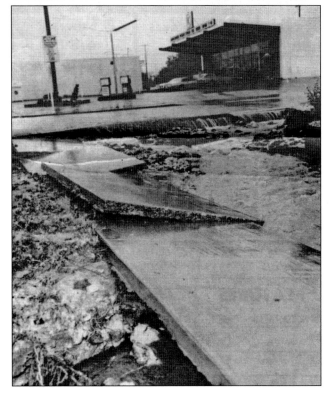

FLASH FLOODING. The irony of a town built on an alluvial fan plain is captured in this 1977 *Desert Sentinel* photograph of flood damage from Hurricane Doreen. An alluvial fan is a land formation made up of loose sand and rocks, including boulders washed down from an adjoining mountain range over a very long period of time.

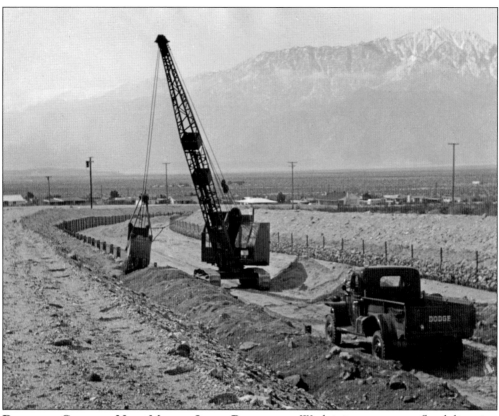

DIVERSION CHANNEL NEAR MISSION LAKES BOULEVARD. Work is in progress on flood diversion channels to help protect the town from flash flooding.

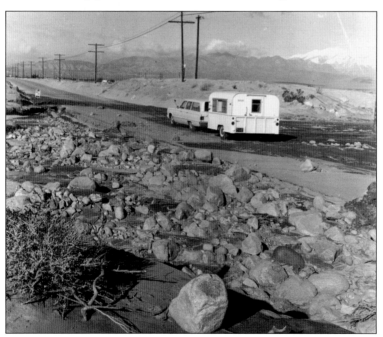

TRAVEL HAZARDS. Even while protecting the settled parts of town from flash floods, several washes or dry creek beds make travel into and leaving town difficult at times. Flash floods are a normal part of desert life. This photograph was taken on Dillon Road approaching Desert Hot Springs.

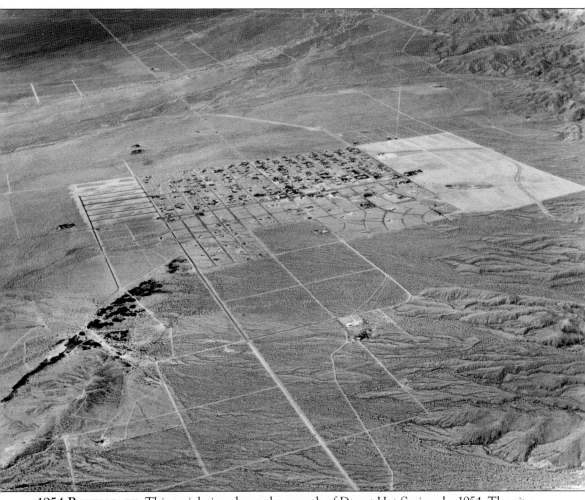

1954 PHOTOGRAPH. This aerial view shows the growth of Desert Hot Springs by 1954. The city grew more rapidly in recent years as housing has spread beyond the central core. The city grew from a hamlet of roughly 20 people when Coffee built his first bathhouse in 1941 to nearly 28,000 people today.

The Last Resort

by buzz gambi

HOMEWARD BOUND. George "Buzz" Gambill captured a lot of the residents' feelings about Desert Hot Springs—the desert vortex of water, wind, earth, and sun at top of the valley.

Two

HOMESTEADERS

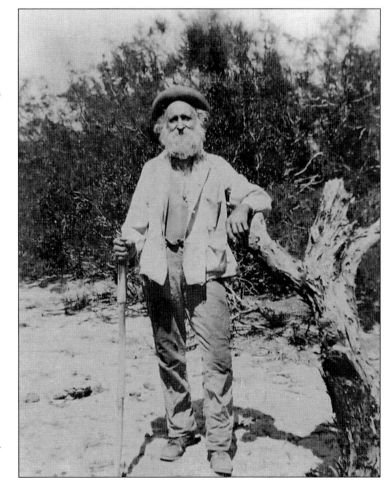

OLD MAN COOLIDGE. In 1900, the only people likely to be living in the desert north of Palm Springs would have been a small Cahuilla population at Seven Palms, a water source, and Dutch Frank, a wandering prospector who always rode a burro. Dutch Frank never claimed a homestead. He lived outdoors in mesquite pockets near water. By 1912, Old Man Coolidge, a prospecting partner of Dutch Frank, had filed for a 160-acre homestead near Two Bunch Palms, another known water source. Coolidge had a beard, walked with a staff, and never owned a burro or gun. (Courtesy of Cabot's Pueblo Museum.)

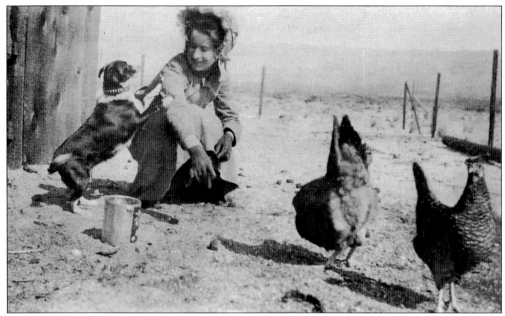

A Brave Woman. By 1912, Hilda M. Gray was living on a homestead just south of Two Bunch Palms where she went every day for water. Along with her burro Babe and dog Trixi, she took care of a flock of chickens. Hilda was small, feminine, hardworking, and a rugged pioneer. She homesteaded for four years before returning to Arcadia, California, to resume her career as a legal secretary. (Courtesy of Cabot's Pueblo Museum.)

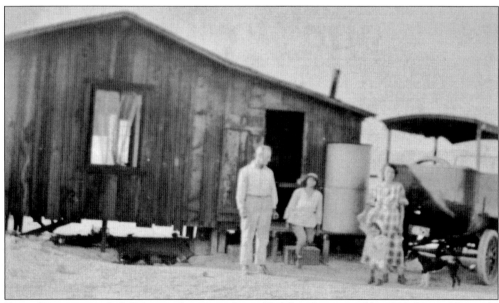

Riley Homestead. Jack Riley was known to have filed for a homestead by 1912. He and his wife, Anne, built their first house near the intersection of what are now Dillon and Mountain View Roads. (Courtesy of Cabot's Pueblo Museum.)

GETTING WATER. Jack Riley and his daughter Virginia haul water to their home. This was a duty necessary every day. Other tasks were gathering firewood, hunting rabbits, building cabins, and making bread.

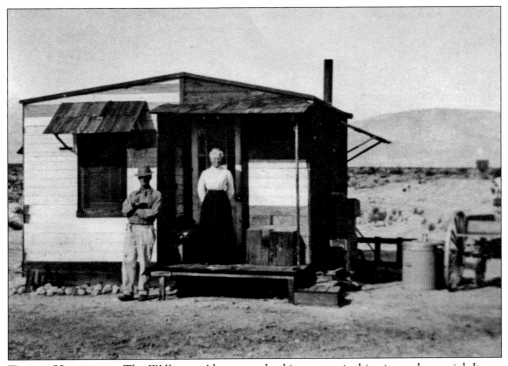

TYPICAL HOMESTEAD. The Williamses' homestead cabin was typical in size and material. It was sparsely furnished but adequate and reasonably comfortable. No other cabins were close enough to be seen.

First Schoolteacher. Another 1912 arrival was 20-year-old Ethel Rouse, the first schoolteacher. Imagine her surprise to discover there was no schoolhouse. Jack Riley's abandoned first shelter, a dugout, was patched together for use as a school. Before supplies were collected, the children learned to write by using their fingers in the sand. (Courtesy of Cabot's Pueblo Museum.)

First School. The dugout was 12 by 14 feet and recessed four feet into the ground. With the addition of corrugated iron salvaged from wrecked freight cars, scrap lumber, and brush on the roof for insulation, the first schoolhouse was established.

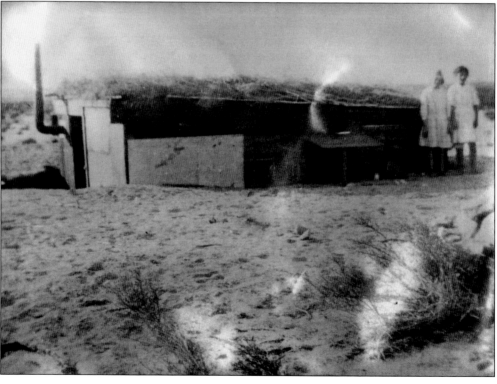

FIRST STUDENTS. There was no place for Ethel Rouse to live, so she stayed with Mercy McCarger, known as the Widow McCarger. The widow's children, along with a few others, became the first students in the hole-in-the-ground school.

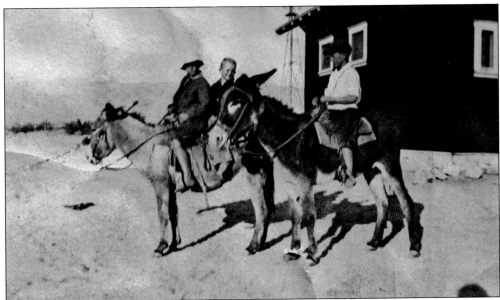

STUDENTS RIDING TO SCHOOL. Children of two early homestead families rode to school on burros. Seated on the light-colored burro are Osborne Edwards and his brother Dallas Edwards. Harold Hicks rides the burro on the right, Jack. (Courtesy of Brian Edwards.)

The United States of America,

To all to whom these presents shall come, Greeting:

WHEREAS, a Certificate of the Register of the Land Office at **Los Angeles, California,**

has been deposited in the General Land Office, whereby it appears that, pursuant to the Act of Congress of May 20, 1862,

"To Secure Homesteads to Actual Settlers on the Public Domain," and the acts supplemental thereto, the claim of

Cabot Abram Yerxa

has been established and duly consummated, in conformity to law, for the **southeast quarter of Section thirty-two in Township two south of Range five east of the San Bernardino Meridian, California, containing one hundred sixty acres,**

according to the Official Plat of the Survey of the said Land, returned to the GENERAL LAND OFFICE by the Surveyor-General;

NOW KNOW YE, That there is, therefore, granted by the UNITED STATES unto the said claimant the tract of Land above described; TO HAVE AND TO HOLD the said tract of Land, with the appurtenances thereof, unto the said claimant and to the heirs and assigns of the said claimant forever; subject to any vested and accrued water rights for mining, agricultural, manufacturing, or other purposes, and rights to ditches and reservoirs used in connection with such water rights, as may be recognized and acknowledged by the local customs, laws, and decisions of courts; and there is reserved from the lands hereby granted, a right of way thereon for ditches or canals constructed by the authority of the United States.

IN TESTIMONY WHEREOF, I, **Woodrow Wilson**

President of the United States of America, have caused these letters to be made

Patent, and the seal of the General Land Office to be hereunto affixed.

GIVEN under my hand, at the City of Washington, the **SEVENTH**

(SEAL.) day of **FEBRUARY** in the year of our Lord one thousand

nine hundred and **EIGHTEEN** and of the Independence of the

United States the one hundred and **FORTY-SECOND.**

By the President: *Woodrow Wilson*

By *M. P. Le Roy*, Secretary.

S. D. C. Lamar,

Recorder of the General Land Office.

RECORD OF PATENTS: Patent Number**616230**.... 6—2137

CABOT'S HOMESTEAD CLAIM. After learning from Old Man Coolidge about his homestead near Two Bunch Palms in 1913, Cabot Yerxa filed his 160-acre claim nearby. He was granted the land on February 17, 1918, during the presidency of Woodrow Wilson. (Courtesy of Cabot's Pueblo Museum.)

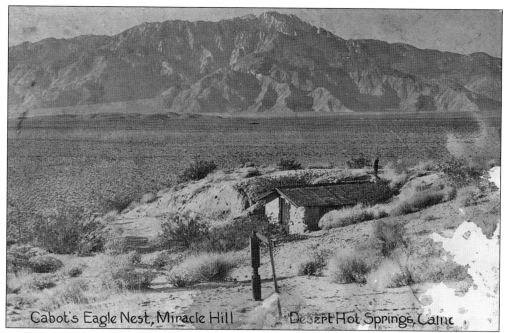

Cabot's Eagle Nest, Miracle Hill Desert Hot Springs, Calif.

EAGLE'S NEST. Cabot Yerxa, who arrived in the desert in 1913, built his first house, Eagle's Nest, on the side of Miracle Hill. Dug into the ground, it had no windows but was secure from the elements. Mount San Jacinto across the Coachella Valley looms in the background.

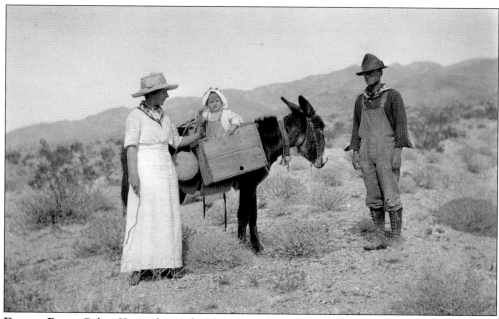

DESERT BABY. Cabot Yerxa; his wife, Mamie; and son Rodney pose for a picture. The round canteen on the side of the burro is on display at Cabot's Pueblo Museum along with Cabot's other collected artifacts. (Courtesy of Cabot's Pueblo Museum.)

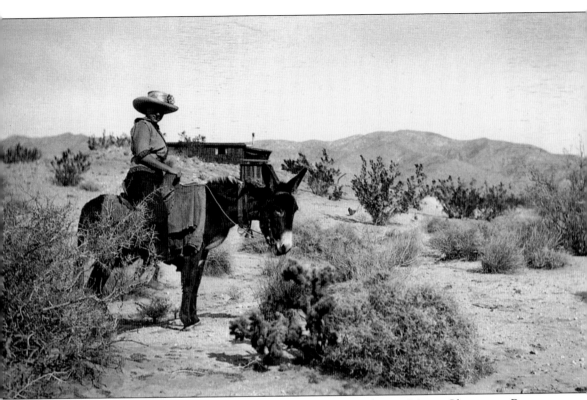

TRUSTY BURRO. Mamie Yerxa sits astride Cabot's favorite burro, Merry Christmas. Burros were essential animals in the desert since they were able to fend for themselves, endure desert heat and cold, and serve as pack animals or for human transportation. (Courtesy of Cabot's Pueblo Museum.)

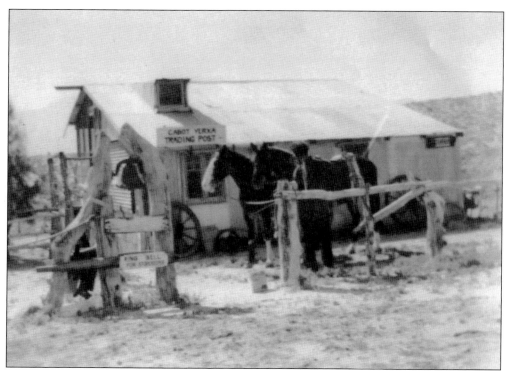

FIRST TRADING POST. Cabot Yerxa's first trading post met the needs of other homesteaders and desert visitors. Some of the items sold were women's high-buttoned shoes, corsets, coyote traps, ammunition, tobacco, cloth, dynamite, human skulls from Alaska, and animal skins.

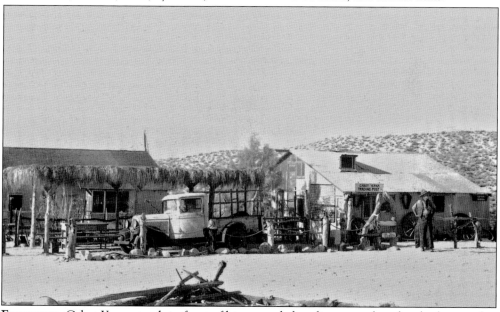

EXPANSION. Cabot Yerxa stands in front of his expanded trading post where he also kept snakes and chuckwallas as pets. Many famous people, including movie stars; Louis Sobol, top columnist for the New York *Journal American*; and Jack Krinder, owner of the 21 Club in New York City, stopped by while visiting the area.

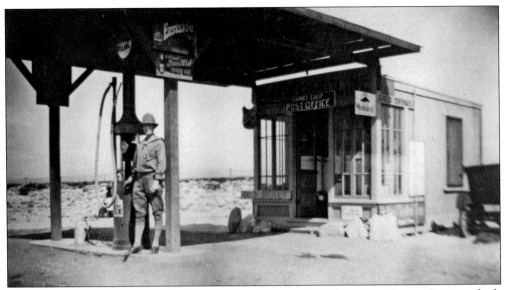

TRAIN STOP. Transportation to the desert was mainly by train with a stop at Garnet Station, which also served as a post office and a place to get water, cold drinks, and gasoline. An unidentified woman stands next to the gas pump.

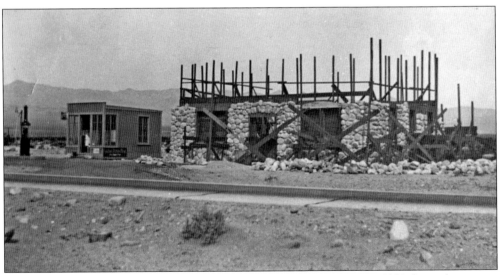

NEW BUILDING AT GARNET STATION. This view of Garnet Station prior to 1920 shows the process of constructing a rock building. Along with a post office and gas station, the new building included a restaurant.

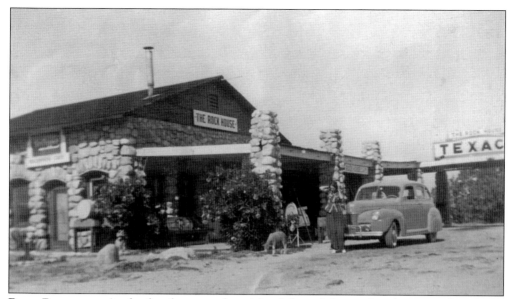

ROCK BUILDINGS. As the first homesteaders either left in defeat or found a way to live in the desert, rock houses began replacing scrap wood shacks. The Rock House store, restaurant, and gas station, built in the 1920s, served travelers on what is now Varner Road near Mountain View Road. This main road through the Coachella Valley was built for the construction of the aqueduct to channel water from the Colorado River to Los Angeles.

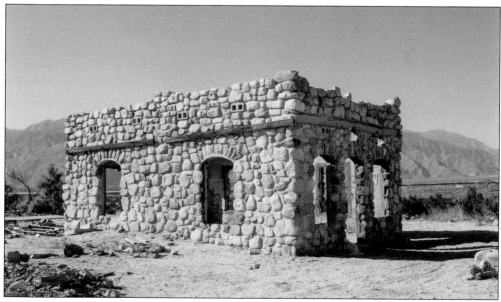

DERELICT BUILDING. During World War II, the Rock House fell into disuse, and the construction of Interstate 10 in 1953 sealed its fate. Yet its sturdy rock walls remained for decades until vandalism determined they be torn down in 2011.

PICTURESQUE ROCK HOUSES. Durable rock houses were built by the hardy settlers who chose to live on the desert alluvial plain extending south from the Little San Bernardino Mountains. Rocks were a plentiful and free building material. Cooler in summer and extremely durable, these rock houses remain as homes on the streets of Desert Hot Springs.

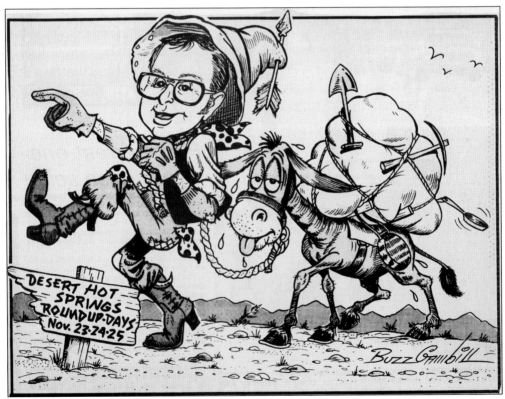

ROUND UP DAYS. Cartoonist Buzz Gambill used a cartoon to remind residents and visitors of how early settlers crossed the desert with only a trusty burro and a small pack of equipment.

Three

L.W. Coffee's Vision

Aerial View, 1937. Note the future Pierson Boulevard running from the center of the photograph into the valley. In 1932, L.W. Coffee, a Los Angeles land developer, visited Cabot Yerxa at his store in Moorpark, California, at the request of a mutual friend, Bob Carr, who homesteaded with Cabot in Desert Hot Springs in 1913. Cabot told Coffee of his discovery of hot mineral water at his homestead on Miracle Hill, northeast of Palm Springs. Coffee was intrigued and visited the area, and he began to develop a vision of a town devoted to health and wellness. That town eventually became known as Desert Hot Springs.

WILLIAM JOHN "AUBREY" WARDMAN (1877–1961). Wardman was a Southern California businessman and land developer who made his fortune in oil and the telephone business. He lived in Whittier, California, about 100 miles west of Desert Hot Springs. Aubrey was dedicated to his community and made many donations to this city. He was always looking for new venture and had become familiar with parts of the Coachella Valley, having participated in an early land development in Palm Desert. In the early 1930s, he obtained 160 acres of undeveloped land from Ford Beebe in the center of what would eventually become Desert Hot Springs. Two business associates were sent by Aubrey to investigate the property, and they reported that the land was useless and should be given up for taxes. Wardman did not take their advice and held the land. In 1940, he agreed to join in a land trust formed by L.W. Coffee. During the early years of the development of Desert Hot Springs, Wardman helped fund many projects for this new town, notably by donating the land for the development of the town's first park and community center, now known as Wardman Park.

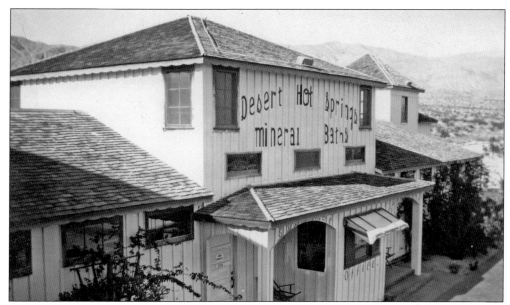

COFFEE'S HOT MINERAL BATHHOUSE. The first bathhouse was built in 1941. The wooden building shown above was the largest structure of any located in what Coffee was now calling Desert Hot Springs, which had a total of 22 citizens when the bathhouse opened. Over 2,000 visitors converged on the spa for its grand opening. There were no services available or rooms for the celebrants, so many of the visitors slept in their cars or camped out on the open desert. The pools and changing rooms of the spa looked out over the desert, and it was a welcome sight for Coffee's customers who braved the unimproved, dusty, and hot dirt roads from the highway some six miles away.

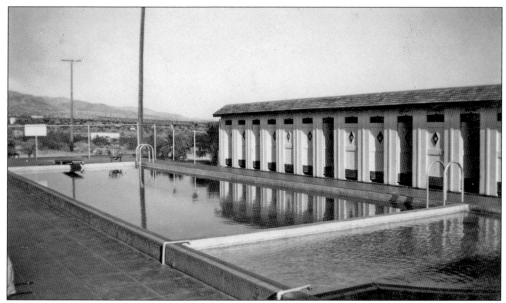

BATHHOUSE POOL. This photograph shows the pools and changing rooms of the bathhouse in 1942.

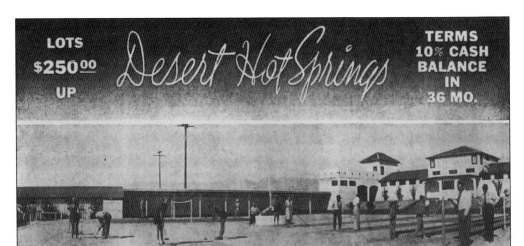

CABIN SITES IN DESERT HOT SPRINGS. Coffee left the bathhouse in the hands of William Tarbutton and returned to Los Angeles to promote the cabin sites.

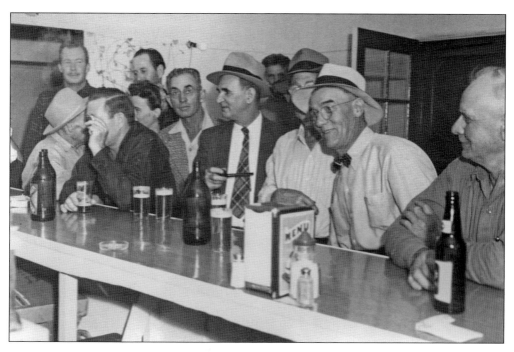

THE IDLE HOUR CAFÉ. In 1941, C.B. and Lenora Dodd opened the Idle Hour Café on the corner of Palm Drive and Pierson Boulevard. The café, having the only electric generator in town at the time, quickly became the social and cultural center of Desert Hot Springs. In the 1948 photograph below, "Mama" Dodd (center) holds court to a very busy lunch rush.

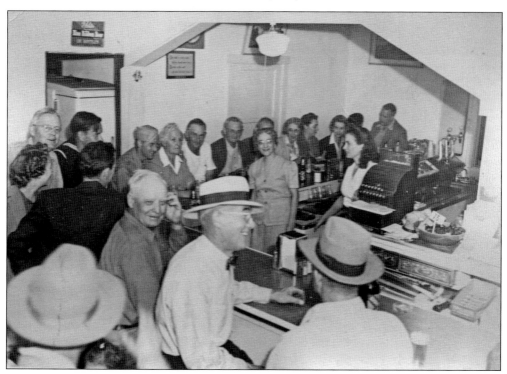

GATHERING ON PATIO. The Idle Hour Café served many roles in the early development of the city. The patio was a gathering place for the townspeople and even served as the site for Sunday Mass before the Catholic church was built. The Idle Hour functioned as an informal post office when mail was hauled to the café from the post office at Garnet at L.W. Coffee's expense. Many movie stars had their weekend houses here, and Mama Dodd would bake pies for Ida Lupino and Louis Hayward. Gen. George Patton's troops, who were training in Palm Desert, were frequent visitors.

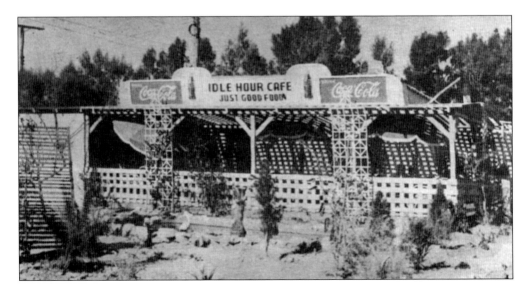

C.C. Covey's Village Market and Realty Office on Pierson Boulevard near Palm Drive. This 1945 photograph shows the village in post–World War II transition with cars and horses competing for space in front of the store. Note the new electrical power lines behind the store. Telephone service was beginning to make its way to the village, and L.W. Coffee paid to install streetlights on Palm Drive.

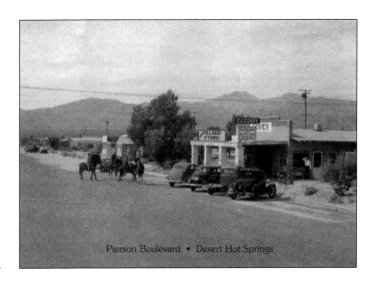

Pierson Boulevard • Desert Hot Springs

Now Accepting Reservations for The Fall and Winter Season

The Blue Heaven Rancho

"The Finest Guest Ranch on the Desert"

Own Hot Water Well

and

Roman Bath

Viola Dinsmore, Owner

Desert Hot Springs Phone 930

The Blue Heaven Rancho. Viola Dinsmore owned the property directly across Palm Drive from Coffee's Bathhouse on Eighth Street. In 1933, she pitched a tent on the corner and began to develop her land, building her guest ranch, the Blue Heaven Rancho, shortly after Coffee built his bathhouse. She had her own hot water well, planted a garden, and raised chickens. The Blue Heaven Rancho provided a place for travelers visiting the bathhouse to rest for the night and get a hearty breakfast the next morning. Viola maintained her property until the mid-1960s and was an important civic leader. Today, her property is the site of a large church and a large modern spa and hotel.

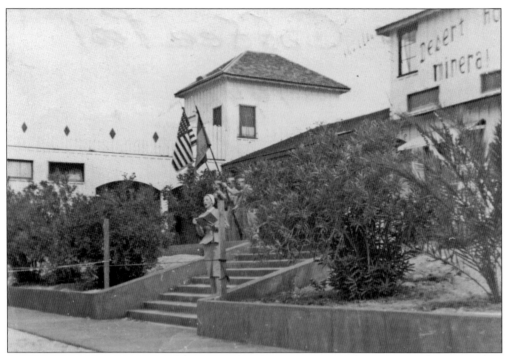

MEMORIAL DAY, 1946. Civic celebrations played an important role in the development of an identity. In the early days of the community, L.W. Coffee, along with Aubrey Wardman, Viola Dinsmore, and Cabot Yerxa, was instrumental in funding these small, but important, celebrations. Coffee was not only civic minded and very generous, he was also a great promoter. The town's first Memorial Day remembrance was held in 1946. This 1946 photograph shows the beginning of the celebration on the steps of Coffee's Bathhouse.

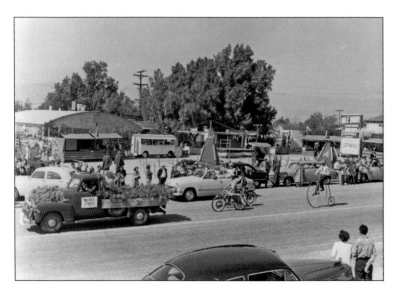

POPPY DRIVE. A post–World War II Veteran's Day parade passes the still-bustling Idle Hour Café on Palm Drive. The poppy drive was an important postwar activity throughout America. Sales of poppies helped support disabled veterans.

46

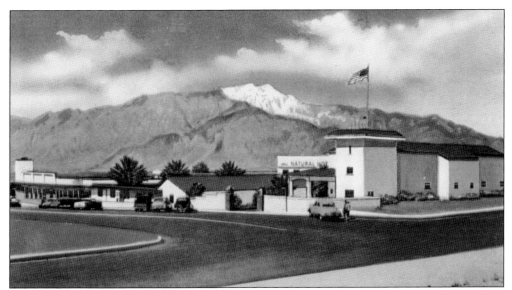

THE NEW SPA. In 1947, Coffee's original bathhouse was destroyed by fire, and a new structure, made primarily of nonflammable material (clay roof, brick and stucco walls, and concrete), was built in its place. This artist's rendering was used to publicize the new spa. The artist took some liberties with the landscaping, which looks like it would be more at home on the coast than in the desert.

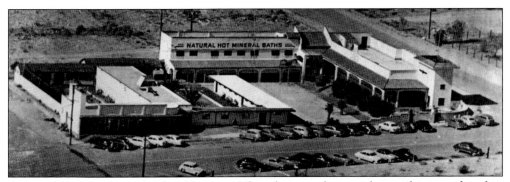

AERIAL VIEW OF COFFEE'S NEW FACILITY. This photograph was taken within months of its opening. The area around the new spa remained largely undeveloped with the exception of Viola Dinsmore's property across the street. Many motels began springing up, especially on Fifth Street between Palm and Cactus Drives. The motels housed many of the visitors who flocked to Coffee's during the high season.

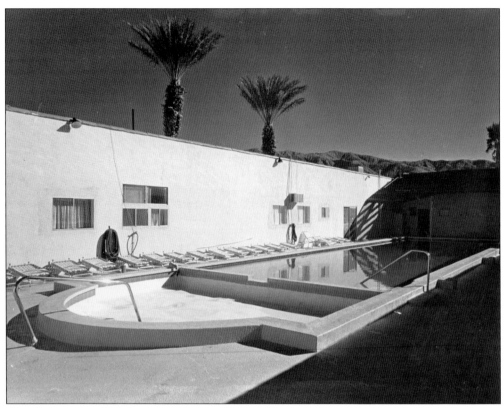

NEW BATHHOUSE. The features of the new Coffee's Natural Mineral Baths included pools, shown in the photograph above. The main pool was advertised as being 24 by 78 feet with a maximum depth of 9 feet. It and the children's pool in the foreground had a constant flow of fresh, warm water, maintained at an average temperature of 90 degrees Fahrenheit. The photograph below is of the interior of the men's bathhouse featuring its new hot soaking tubs, massage tables, and lounge, emphasizing space, cleanliness, and modern features.

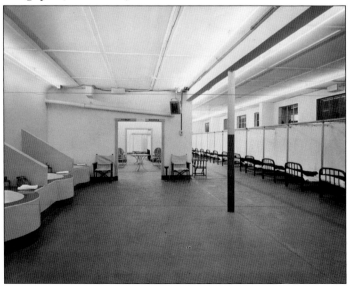

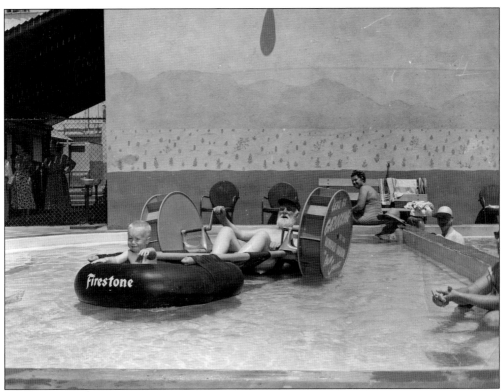

PROMOTIONS FOR THE NEW SPA. In the 1955 publicity photograph shown above, Coffee, the true promoter, uses his kiddie pool for a demonstration of a new device. It is noteworthy that he used local character Mike Swan, age 102, and a 2-year-old toddler as a not-too-subtle reference to the health values of his hot mineral water. The 1958 advertisement shown at right emphasizes the relaxing tub baths, cot sweats, and scientific massage, giving the spa a highly clinical air.

DESERT HOT SPRINGS
49ers CENTENNIAL
OCTOBER 8th & 9th, 1949

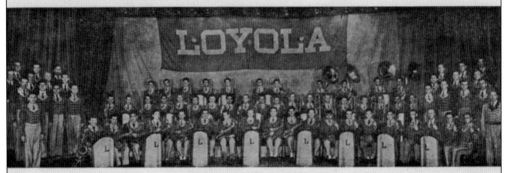

Loyola University Band

GET ON THE BAND WAGON!

★ **Sat. Oct. 8th, 11 A. M. — 49ers Parade!**
over $450,000.00 worth of equipment
500 horses, floats, Bands — Bands — Bands.

★ **Sat. Evening. Variety Radio Show.**
(to be broadcast)
Loyola University Band, Celebrities.

★ GAMES

★ STARS from RADIO and SCREEN

★ DOG SHOW

★ FRONTIER TOWN
(with all the trimmings)

★ MOVIES (Free)

★ MODERN and WESTERN DANCING
(Sat. Eve.)

★ Barbecue

Dress Western and have fun!

Admission 50c
Plus Tax Includes Barbecue.

Fun for all for a worthy cause!

L. W. COFFEE, General Chairman

49ERS CENTENNIAL. L.W. Coffee organized the centennial celebration of the California Gold Rush. Even at 1949 prices, this event at 50¢ was a real bargain.

1947 POSTCARDS. Postcards were considered a very effective way to advertise an attraction. Coffee used postcards to promote his bathhouse from at least 1947 until his death. The postcard below shows Coffee and an unidentified woman in the foreground at Coffee's main pool. This is a rare picture of Coffee. Note how the spa is featured as a desert oasis when contrasted with the barren Little San Bernardino Mountains in the background.

The original L. W. Coffee Bath House, 1947
Courtesy of the Desert Hot Springs Historical Society and Sidewinders Restaurant

DESERT HOT SPRINGS
Home of the Healing Waters

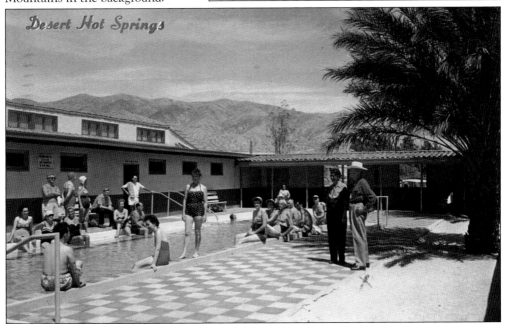

Desert Hot Springs

LOCAL BEAUTIES. These ladies were used in this photograph to publicize the building lots that remained available in Desert Hot Springs after Coffee's death in 1957. Aubrey Wardman continued

URE SECURITY

esert Hot Springs

UY A Lot. Build A Home

Growing Community

OPPORTUNITIES

PRINGS REALTY CO.

st North of Pierson ISABEL A Beasley MGR

LOTS ACREAGE INFORMATION

to use a variety of brokers to sell cabin sites until his death in 1961.

COFFEE

LILLIAN T. 1872-1952
LAWRENCE W. 1876-1957

FOREST LAWN CEMETERY IN GLENDALE, CALIFORNIA. L.W. Coffee was not a wealthy man, often saying that he had made and lost several fortunes over the years and was sometimes at odds with his partners over money, but his legacy is that he believed in his new city, as outlined in his booklet "Desert Hot Springs Why?" He was a true visionary who, more than any other individuals, created the spa industry that continues to be the backbone of the city to this day. He believed in the water and promoted it to the end of his life. L.W. and Lillian Coffee were interred at Forest Lawn Cemetery in Glendale, California.

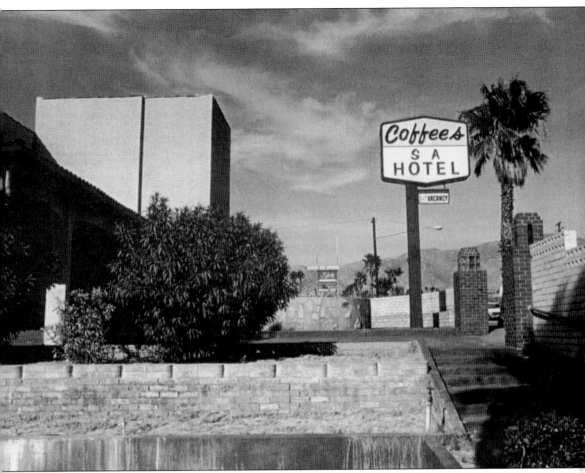

THE END OF THE BATHHOUSE. After Coffee's death, the spa continued operating and was leased for several years by William Schultz, who later became one of the city's mayors. It changed hands, sometimes lying vacant for much of the 1960s through the 1980s. Finally, the south wing of the spa was demolished in August 1990. The rest of the spa was razed in January 1991. Sadly, Coffee's spa did not survive, but the spa industry continues to draw thousands of visitors seeking the healing waters every year.

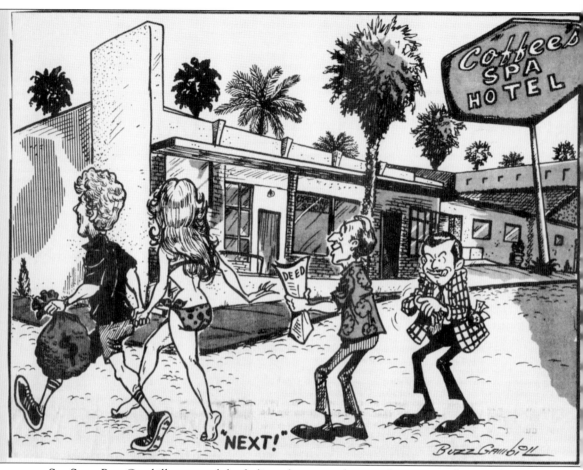

SPA SALE. Buzz Gambill expressed the feeling of many residents in this cartoon showing the greed of some of the later owners of the spa.

Four

CABOT'S PUEBLO

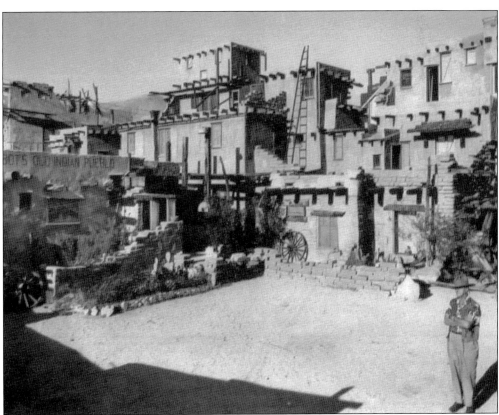

UNIQUE TREASURE. Cabot Yerxa was born in 1883. He began building this pueblo in 1941 when he was 58 years old and finished nine years later. It was his home and museum until he died in 1965. It has always been a major tourist draw. In the early 1960s, Cabot estimated 50,000 people toured his museum; in 1963, the *New York Times* ran an article on the pueblo. It still welcomes visitors today.

BUILDING AND CONSTRUCTION. Cabot did most of the work on his pueblo himself. In 1941, he dug into a hillside above the city to create a back wall for the structure. Lumber from abandoned cabins, bricks made of the desert earth, and other found materials inspired his design; there was no blueprint. Most of the building was covered in tarpaper and then cement was applied to create an adobe look. He said it was 5,000 square feet, 35 rooms, 150 windows, and 65 doors. Most rooms are intimate, irregularly shaped, and create a labyrinthine effect. Raw wood, exposed rocks, and bricks foster a primitive atmosphere. Cabot's strategies for cooling the pueblo in summer included small windows and narrow passages to intensify desert breezes.

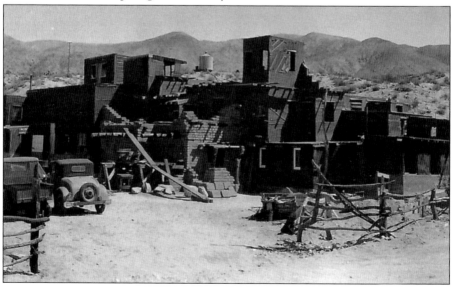

CABOT WITH WIFE PORTIA. Cabot Yerxa married his second wife, Portia Fearis Graham, in 1945 while working on the pueblo. They moved into the pueblo around 1950 and lived there for 15 years. Cabot built a special one-bedroom apartment on the second floor of the pueblo just for her. His tours included not only his museum rooms but also original living quarters on the first floor, which included a kitchen, dining room, and living room with an earthen floor. Portia's quarters were off limits. She taught inspirational, self-help courses in big cities, so Cabot built a classroom at the pueblo so she could continue her teachings. Cabot and Portia regularly entertained artists, Native Americans, and local celebrities at the pueblo.

ON THE DESERT SINCE 1913. Cabot's big upstairs museum room contained souvenirs and artifacts from his early travels to the Alaska Gold Rush in 1900 and Cuba soon after the Spanish-American War, plus his observations of desert fossils, animals, and the ways of Native American cultures. His collection also included several hundred photographs that he took during his travels. These items were all on display and used by Cabot to spin his stories and facts around. He called his museum tours "lectures" and wanted to educate people about the desert, the plight of Native Americans, and other cultures he had encountered in his life's adventures. Cabot was not only a museum guide and promoter of desert ways, he was also an artist and writer. Cabot hung his paintings in every room for his visitors and friends to buy. He wrote numerous newspaper articles, but the most memorable were the newspaper columns he wrote for the local *Desert Sentinel.* This series was called "On the Desert since 1913," reminiscing about his early life as a homesteader.

COMMUNITY SERVICE. The sign above his head shows his characteristic humor, but it truly reflected how many felt about his pueblo. During the 1940s, he helped found several Desert Hot Springs city institutions, such as the Desert Improvement Association, the library, service clubs, the Masonic chapter, and a lodge of the Theosophical Society. The local newspaper often called him "Mr. DHS." In 1965, he was honored as grand marshal in the Desert Hot Springs Cityhood Parade. He was proud of what he had accomplished and proud of the city that considered him a founding father. Cabot wrote, "It is my hope that this museum will always be a point of interest and instruction, dedicated to the idea of teaching young and old about life on the desert, the pioneer life and animals." Today, the Cabot Museum Foundation proudly carries on his tradition.

DESERT HOT SPRINGS FOUNDERS. Four influential founders of the city are, from left to right, Aubrey Wardman (who provided major financial support for the ideal of a curative "spa city"), Cabot Yerxa (visionary and builder of the old Indian pueblo), Viola Dinsmore (owner of the Blue Heaven Rancho), and L.W. Coffee (builder of the first hot water spa and land developer).

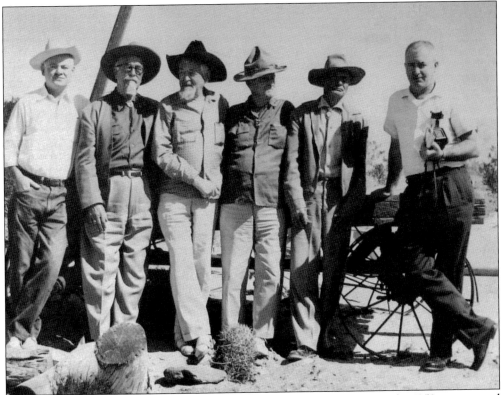

LOCAL CELEBRITIES. The general appearance of the desert's male society in the 1950s is conveyed by the hats and some smiles. Third from the left is Harry Oliver (formerly Hollywood set designer, editor of a humorous quarterly, the *Desert Rat*, and builder of a pseudo-adobe house, Old Fort Oliver, at nearby Thousand Palms); fourth from the left is Cabot Yerxa; he is followed fifth from left by Bill Keyes (owner of Keyes Ranch, now a feature of Joshua Tree National Park).

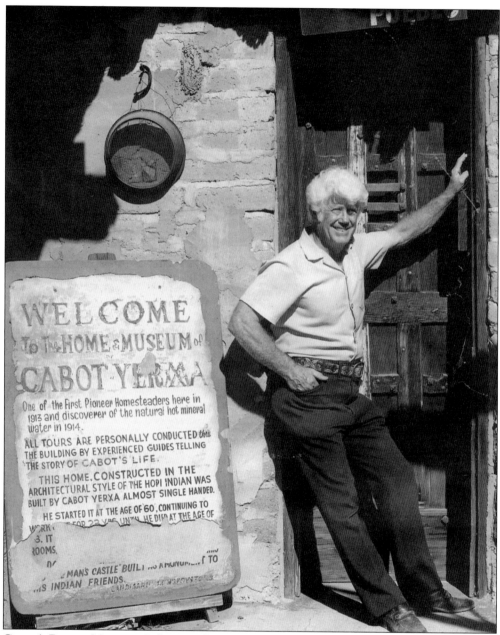

The sign in the photograph reads:

WELCOME
To The HOME & MUSEUM of
CABOT YERXA

One of the First Pioneer Homesteaders here in
1913 and discoverer of the natural hot mineral
water in 1914.

ALL TOURS ARE PERSONALLY CONDUCTED thru
THE BUILDING BY EXPERIENCED GUIDES TELLING
THE STORY OF CABOT'S LIFE.

THIS HOME, CONSTRUCTED IN THE
ARCHITECTURAL STYLE OF THE HOPI INDIAN WAS
BUILT BY CABOT YERXA ALMOST SINGLE HANDED.

HE STARTED IT AT THE AGE OF 60, CONTINUING TO
WORK . . . FOR 23 YRS UNTIL HE DIED AT THE AGE OF
3. IT
ROOMS.

MANS CASTLE BUILT AS A MONUMENT TO
HIS INDIAN FRIENDS.

CABOT'S PUEBLO MUSEUM. Colbert "Cole" Eyraud bought Cabot's old Indian pueblo in early 1969 and restored it as a museum in Cabot Yerxa's memory. He had known Cabot for about five years prior to Cabot's death, and when he heard that the city was going to tear it down, he formed an organization to raise the money necessary to buy and restore it. It took two years of restoration, and in the early 1970s, Cole opened the doors once again for visitors to see the amazing structure and hear the stories of Cabot Yerxa. Cole trained a number of local high school students to give tours. He charged $1 for an adult and 50¢ for a child. Cole shared Cabot's fondness for the desert, though he served in the Navy from 1943 to 1946, and had been an entrepreneur in Los Angeles until retirement. A colorful personality in his own right and natural yarn-spinner, Cole loved giving tours at the pueblo.

Waokiye. Cole Eyraud invited Hungarian-born artist Peter Toth to carve the huge sculpture of a Native American that still stands on the grounds of Cabot's pueblo. The carving is part of Toth's famous *Trail of the Whispering Giants* project, which consisted of a series of similar carvings placed in each American state and Canadian province to commemorate the Native Americans.

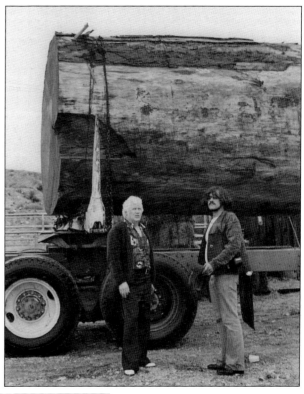

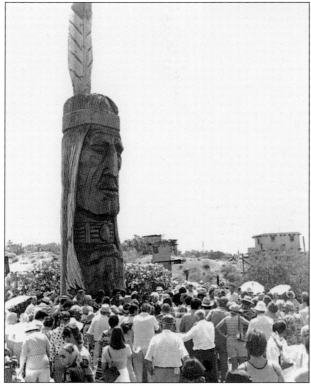

Tourist Attraction. The head is made of an ancient sequoia that was struck by lightning and fell in a nearby forest; the feather is from a different tree. It was dedicated on May 20, 1978, and the sculpture is named *Waokiye*, which is Sioux for "traditional helper." The dedication attracted some Native Rights activists and supporters, continuing the museum's role in promotion of Native awareness for the region. In 2009, Peter Toth returned to "refresh" his sculpture, which had become weathered. It remains a large tourist attraction at the pueblo.

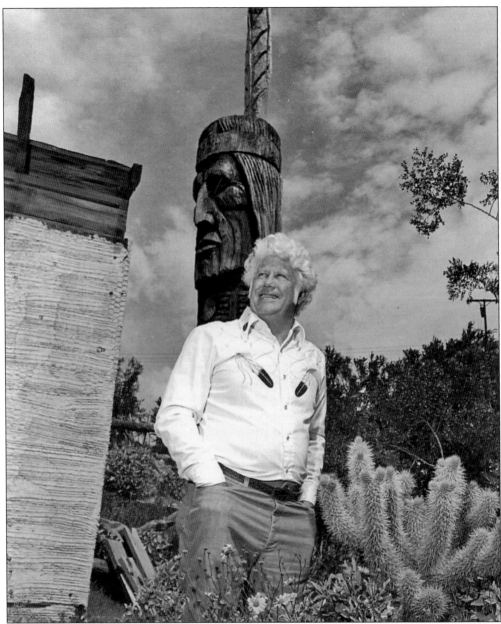

HISTORIC LANDMARK. Cole was active in the community, served on the Desert Hot Springs City Council, and was active in civic affairs. But his heart was at the pueblo. He and some of his family lived at the pueblo until 1996, when Cole died. Cole committed 25 years to the preservation of the pueblo, and it would not be standing today were it not for his dedication to its preservation. After Cole Eyraud's death, his family donated Cabot's Pueblo Museum to the City of Desert Hot Springs. The family's generosity made possible the continuation of a unique cultural resource. As a result, Cabot's wish to always have the museum as a point of interest and instruction is alive and well today. In 2012, the building was added to the National Register of Historic Places, one of only two structures in the Coachella Valley currently listed. Cabot's Museum Foundation holds a number of fundraising events throughout the year.

Five

ANGEL VIEW

ANGEL OF THE MOUNTAIN. On-10,834-foot-high Mount San Jacinto is the prominent white granite formation resembling the wings of a distinct angel. This symbol inspired Leslie Morgan's name for Angel View Crippled Children's Foundation. In keeping with the angel image, miraculous, restorative health benefits have taken place at the facility at 12-379 Miracle Hill Road.

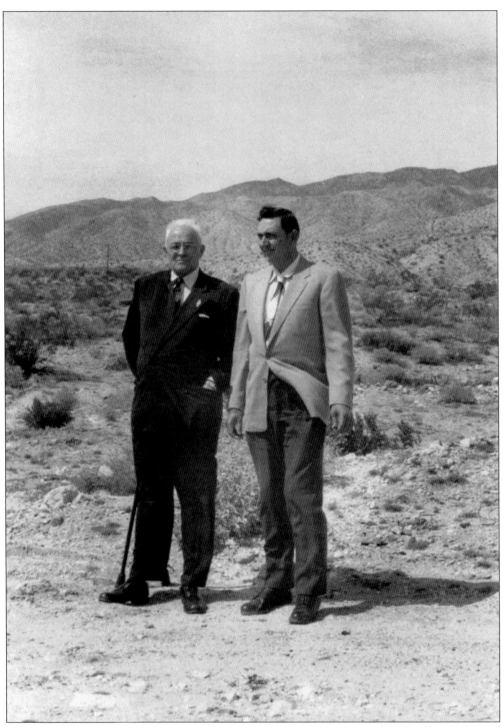

BEGINNING OF A BUILDING PROJECT. The dream, vision, and generosity began when Leslie and Ferne Morgan's son Michael contracted poliomyelitis. Leslie Morgan, on the right, is showing county supervisor Homer Varner the land where the Angel View Crippled Children's Hospital would be built on Miracle Hill Road.

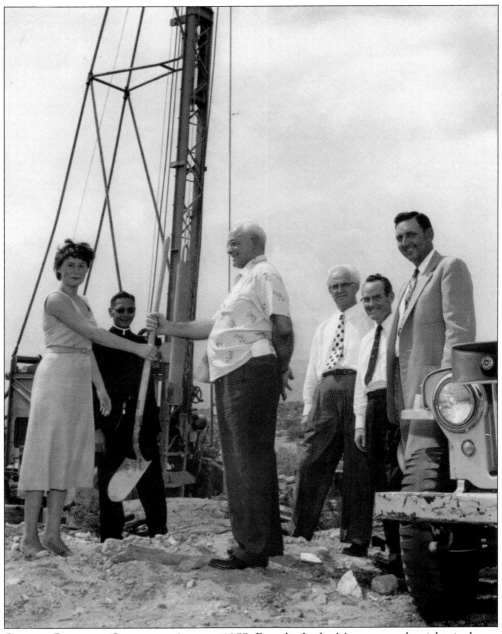

GROUND-BREAKING CEREMONY, AUGUST 1955. Founder Leslie Morgan, on the right, is shown with unidentified dignitaries breaking ground.

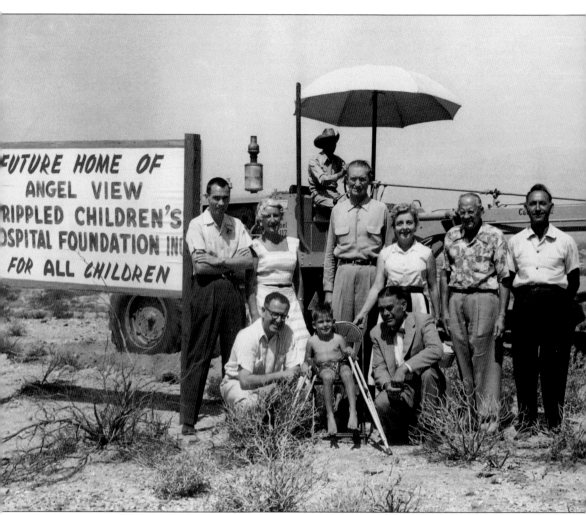

THE SYMBOL OF HOPE. A resolved community of dedicated supporters surrounds a young unidentified boy with crutches as the tractor driver prepares to turn over sand for the future home of Angel View Crippled Children's Hospital. Attendees looked forward to moving into the permanent location from their temporary clinic headquarters at 66-129 Pierson Boulevard.

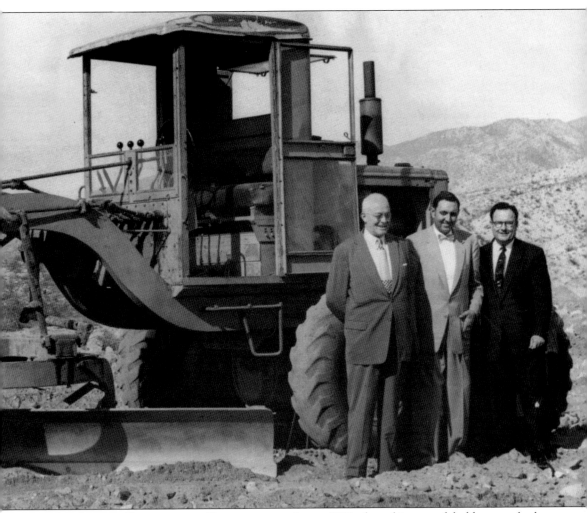

THE GROUND-BREAKING FOR CONSTRUCTION. It was 1956 when this powerful old tractor broke ground. Seen attending the ceremony are, from left to right, Riverside County supervisor Homer Varner, founder Leslie Morgan, and Mr. Aspy.

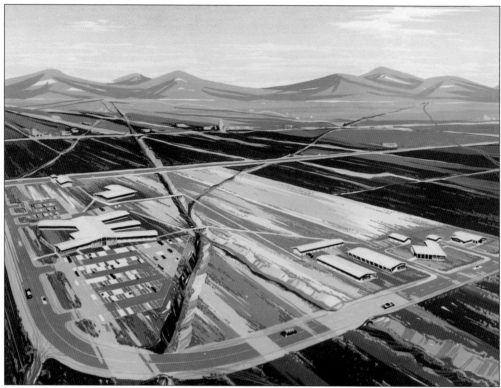

ARCHITECTURAL PLANS AND BLUEPRINTS. Architect R. John Blesch Jr., of the American Institute of Architects, did the hospital's master plan drawings. Once the plans were completed and approved, doctors began seeing patients in their permanent location, as seen below.

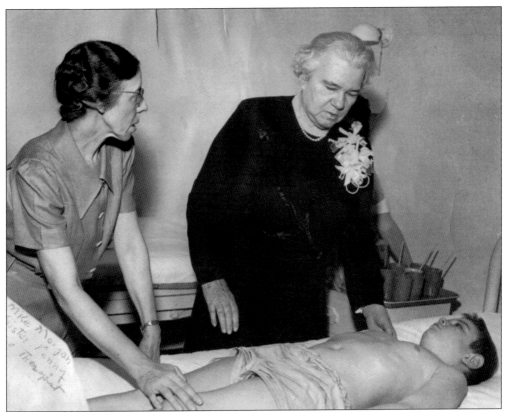

SISTER KENNY. A nurse from Australia became well recognized during the poliomyelitis epidemic and was honored in a 1951 Gallup poll as "The Most Admired Woman," a title previously held by Eleanor Roosevelt since 1946. Elizabeth Kenny was founder of the Minneapolis Rehabilitation Institute and the Sister Kenny Poliomyelitis Hospital of El Monte, where Dr. Robert Bingham adopted her treatment plan and became chief of staff. Pictured above are, from left to right, an unidentified therapist, Elizabeth Kenny, and eight-year-old Michael Morgan at the El Monte hospital on November 9, 1949. Below, Michael is seen as a fully recovered 15-year-old. Dr. Bingham accepted the invitation as health director for Angel View Crippled Children's Foundation from his position as chief of staff at the Riverside County Orthopedic and Poliomyelitis Quarantine Unit.

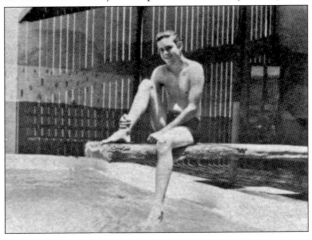

FUNDRAISING PARTICIPATION. All ages and groups of people, including children, were encouraged to save and donate their pennies. At the fundraising event, there was a Penny Carnival Queen. Realtors each gave $100, and the local chamber of commerce campaign raised $30,000.

ENTERTAINMENT. Every opportunity was taken to support Angel View. Tickets were sold for rides at the carnival, a Local-22 Booth Fair, and events in surrounding communities. The hospital auxiliary had thrift shop fashion shows and card parties. Money came from box socials, raffle ticket sales, the Friendship Club, and an ice cream social at the Willets' home.

THE FLYING GREAT-GRANDMOTHER. On July 13, 1956, stepping out of the airplane, Zaddie Bunker of Palm Springs flew her twin-engine Cessna to San Diego, where she appeared on *The Joe Graydon Show* to promote Angel View Crippled Children's Hospital. The ladies auxiliary sponsors met her there in a brand new DeSoto station wagon that was donated to Angel View by Hall Motors of Riverside in May 1956.

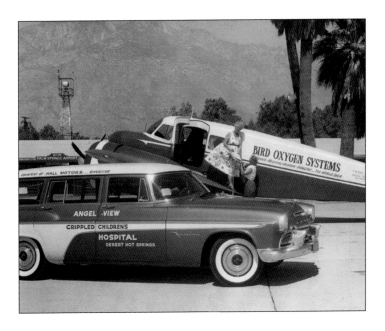

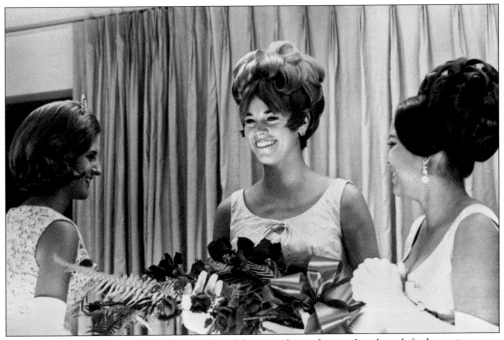

THE FLAMBOYANT FIFTIES. Beehives, the elaborate, dressy hairstyles that defied gravity, were fashionable for beautiful young women of the 1950s. These unidentified ladies of Desert Hot Springs were sponsored to promote Angel View in the Miss Desert Hot Springs and Queen Scheherazade categories at the Riverside County Fair and Indio Date Festival.

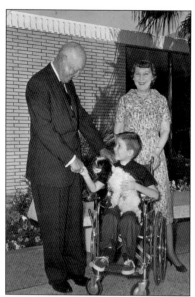

PRESIDENTIAL SUPPORT. Leslie and Ferne Morgan's passion was to raise money for the children's hospital. It seemed like a slow beginning, but their vision inspired others, including Pres. Dwight D. and Mamie Eisenhower, shown shaking hands with an unidentified boy. Bob Hope started entertaining the troops during World War II, while Eisenhower was supreme commander of the Allied forces, and also contributed to Angel View. (Courtesy of Paul Pospesil.)

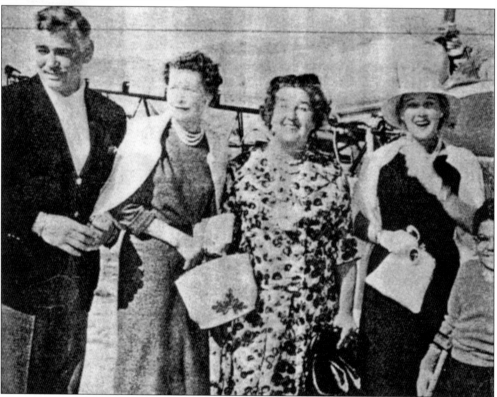

CELEBRITY ENDORSEMENTS. Pictured at the February 18, 1960, ground-breaking ceremony for the Wardman Wing of the hospital are, from left to right, actor Clark Gable, Ester Eaton, Rose Bertram, and Clark Gable's wife, Kay Spreckels. Other supporters, including actor and Mrs. Chuck Connors, with Joseph Magnin, held a fashion show. Alice Faye, Broadway actress, and Leonard Firestone, tire magnate, hosted a luncheon. Donations were received from Sonja Henie, Walter Annenberg, and Frank Sinatra. (Courtesy of *Desert Sentinel*.)

Era Postcard. The comments on the back of this postcard state that the Children's Clinic is a nonprofit, charitable organization maintained entirely by contributions. The postcard helped to spread the word and generate donations. (Courtesy of Dexter Press, Inc., New York.)

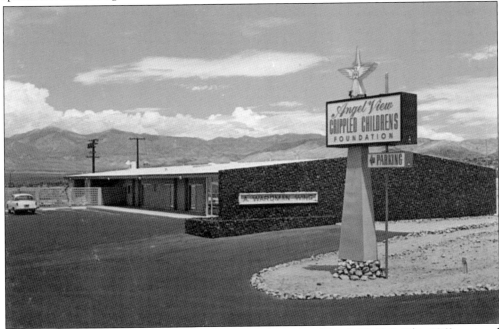

The Wardman Wing. A 16-bed extension was dedicated on March 19, 1961. This 1962 postcard shows the growth and development of Angel View as a result of a devoted community, staff members, doctors, and nurses. According to the California State Hospital inspectors, it was the most modern and up-to-date children's hospital in existence. (Published by Camera Center, Cathedral City, California.)

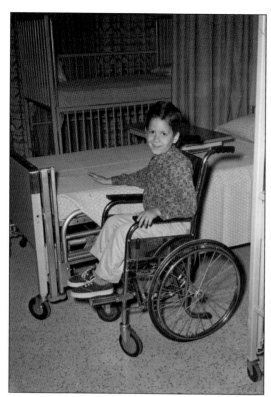

THE RESULT OF PROFESSIONAL TREATMENT. Smiles on the faces of recovering unidentified children indicate that their hard work with therapists is working. Angel View Crippled Children's Hospital opened its doors in 1956 under the California State Crippled Children's Service, the Easter Seal Organization, and the Bureau of Crippled Children's Services. Angel View facilitated the public-spirited citizens who had interest and love for children to give free and voluntary services. The community is proud of the facility, which is in a healthy, sunny, well-equipped location with the advantage of therapeutic hot mineral water.

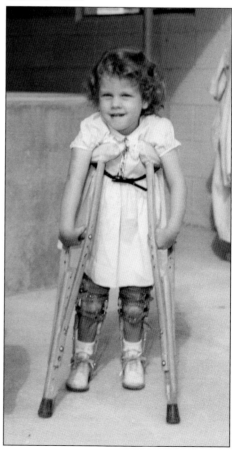

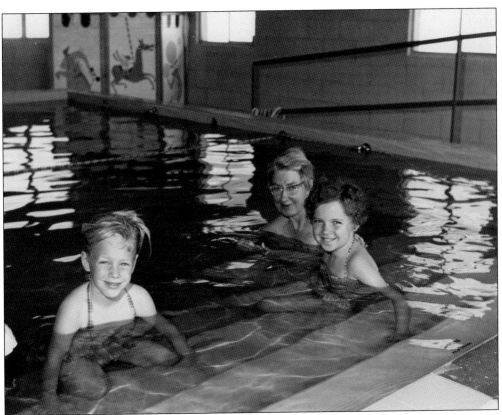

WATER AND PHYSICAL THERAPY. Treatment was provided free of charge for crippled children with poliomyelitis in the 1950s. However, treatment of the painful complications of poliomyelitis, as well as heart and kidney disease, asthma, arthritis, cerebral palsy, and rheumatic fever, continues. Today, Angel View has broadened its mission as a nonprofit organization serving both children and adults with disabilities.

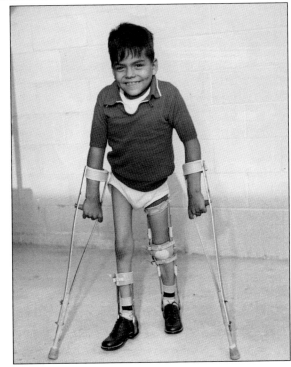

A JOYFUL WISH. The 1988 *Desert Sentinel* holiday wish portrayed in Buzz Gambill's cartoon also reflects the focus of Angel View and its work to bring happiness to children and adults alike.

Six

Dude Ranches

Dude Ranch Era. The Circle K Ranch on Twentieth Street was owned by Warner Baxter, and movies were filmed there, but little remains today of that glamorous era. The B-Bar-H Guest Ranch represented one of the best dude ranches that were so popular in the 1930s and 1940s. The B-Bar-H, named for Lucien Hubbard and Charlie Bender, developed from a citrus farm into a Hollywood getaway destination, attracting movie stars and celebrities from as far away as New York and Chicago.

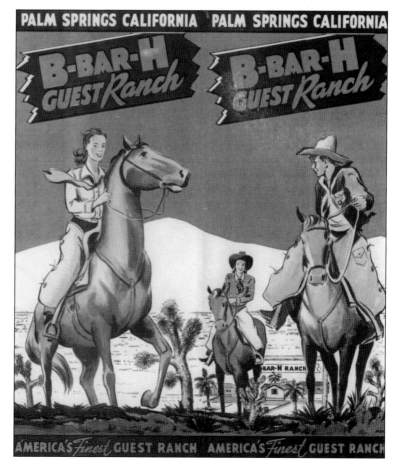

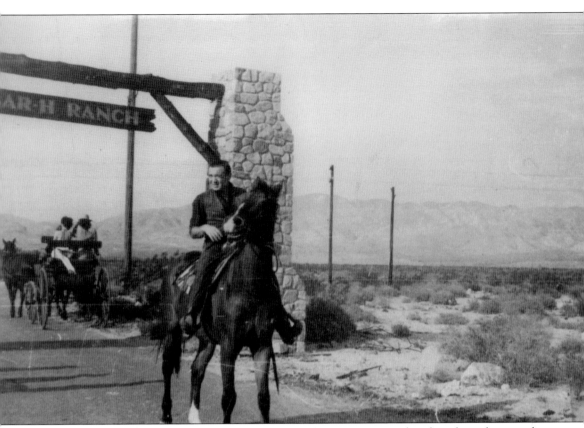

POPULAR PHOTOGRAPH SPOT. The picturesque ranch sign was a popular place for a photograph. Peter Lorre, a popular movie star seen in *Casablanca* (1942) and *The Maltese Falcon* (1941), poses with the buckboard and passengers in background.

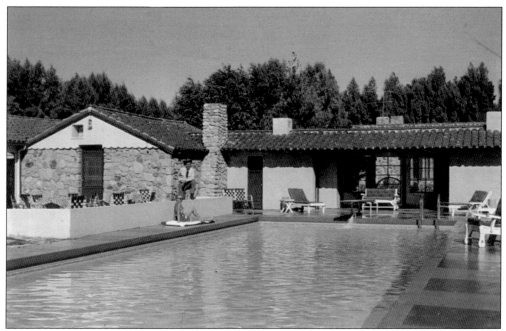

RANCH CLUBHOUSE. The B-Bar-H clubhouse was a popular gathering spot with an indoor bar and outdoor pool. The tennis court was nearby. Clay tile roofs and rock walls combined with stucco were the building materials used on all ranch buildings.

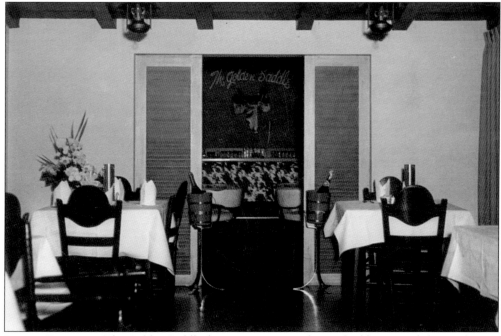

DINING ELEGANCE. The Golden Saddle dining room in an adjacent building served elegant dinners (note the champagne in buckets) as well as Western-style barbecues. On Saturday nights, guests in elegant gowns and Western attire whooped it up at the B-Bar-H's Western dances.

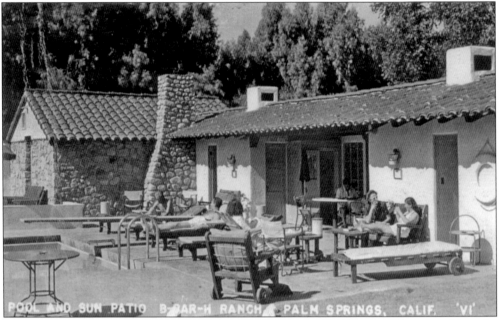

POOL AND SUN PATIO. Sunbathing was especially popular during this time. Note the address for the ranch is shown as Palm Springs. Desert Hot Springs did not come into being until the early 1940s, and even then, it had only 20 residents and a few houses.

SERVANTS QUARTERS. This house shows typical rock-wall and clay tile–roof construction. Tamarisk trees ringed the perimeter of the ranch buildings, providing shade and privacy. Snow-capped Mount San Gorgonio can be seen in the background.

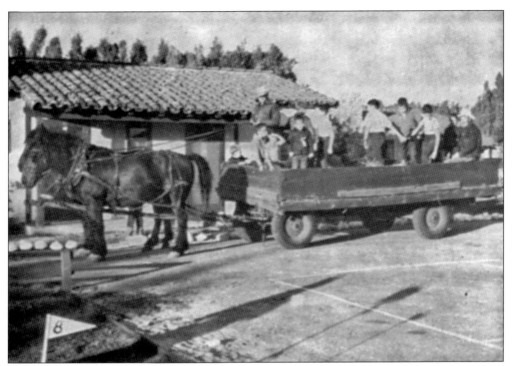

RANCH ACTIVITIES. Children were welcomed at the B-Bar-H, with special activities planned for them. The unidentified children in this picture are going on a hayride.

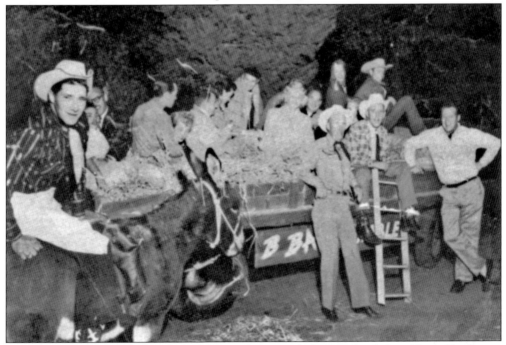

MIDNIGHT HAYRIDE. Unidentified adults are shown ready for a midnight hayride and barbecue. This weekly feature at the ranch included steak sandwiches, green salad, chuckwagon beans, and lots of hot coffee cooked over an open fire by the ranch wranglers.

Go Western this Winter

❧ There's no place like a real California Ranch for an exhilarating Winter Vacation.

❧ Thrill to adventure of the Southwest—riding the range ...swimming, tennis, hiking, camping, hunting, golf, sunbathing in the dry, warm desert.

❧ Or complete quiet in the seclusion of a date grove.

❧ Individual cottages of one, two, three or four rooms... with appointments of the finest hotel, but true to the color of the ranch country. Select, friendly clientele.

Write for illustrated booklet and rates to Dept. D

B-BAR-H RANCH

in the Coachella Valley near Palm Springs

(Mailing address: Garnet, Calif.)

FROM VARIOUS PUBLICATIONS, CELEBRITIES WHO VISITED THE B-BAR-H GUEST RANCH:

MARY PICKFORD	WARNER BAXTER
GINNY SIMS	JANET GAYNOR
MONTIE MONTANA	MERVYN LE ROY
ADOLPHE MENJOU	JOSEPH SELZNICK
BING CROSBY	IRENE DUNNE
SAL MINEO	BARRY BARUCH
RONALD COLEMAN	BONITA HUME
PHIL HARRIS	ALICE FAYE HARRIS
LOUIS SOBOL	SI SEADLER
MAX SCHUSTER	SOL LESSOR
JACK KRINDER	LIONEL BARRYMORE
JOHN RASKOB	JOAN CRAWFORD
MARX BROTHERS	SIDNEY KINGSLEY
TYRONE POWER	DARRYL ZANUCK
WALT DISNEY	MARLENE DIETRICH
WENDY BARRIE	ROBERT TAYLOR
ELEANOR POWELL	BEATRICE KAUFMAN
OLIVIA DE HAVILAND	RITA HAYWORTH
BOB HOPE	JERRY COLONA
RAY MILLAND	DORE SHARY
PETER LORRE	FRANK BOGERT
LEW AYRES	JOHN BARRYMORE
PRESTON FOSTER	GARY COOPER
JOAN FONTAINE	NORMA SHEARER
LUCIENNE HUBBARD	CHARLIE BENDER

CELEBRITY CLIENTELE. This advertisement ran in the *Desert Magazine* in April 1939. While the ranch appealed to all kinds of visitors, celebrities from the movie business seemed especially attracted, as shown by the list of known guests.

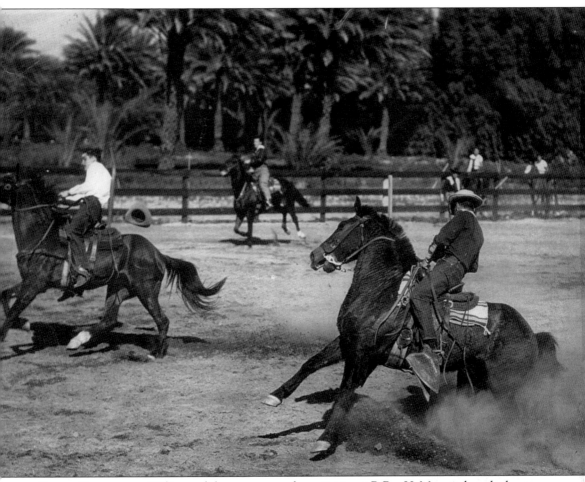

RIDING EXHIBITIONS. Riding and shows were regular activities at B-Bar-H. Mounted on the horse to the left is young Richard Roger, grandson of Jay and Marie Kasler. He has just lost his hat while putting his horse through a demonstration exhibition. Others in the picture are unidentified.

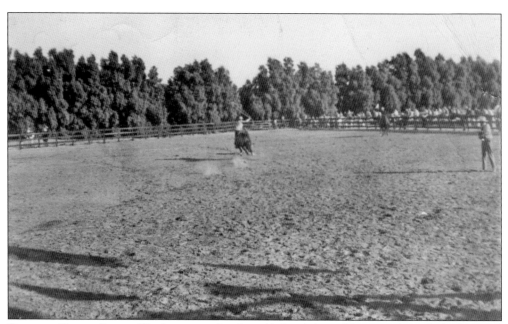

SHOWING RIDING SKILLS. The large crowd gathered behind the rail fence in the right background indicates an important rodeo event is taking place.

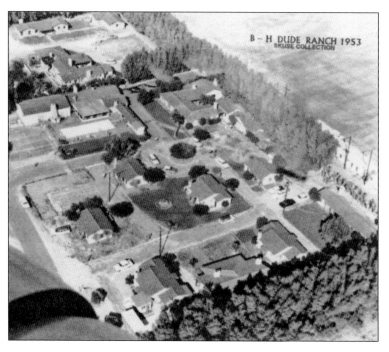

B – H DUDE RANCH 1953
SKUSE COLLECTION

AERIAL VIEW. This 1953 view of the B-Bar-H Ranch shows the layout of the buildings surrounded by tamarisk trees. The large building in the upper left is the Kasler house. Just below it are the clubhouse, swimming pool, and tennis court. The dining room and entrance to the ranch are in the large building next to the trees on the right. The other buildings are guesthouses.

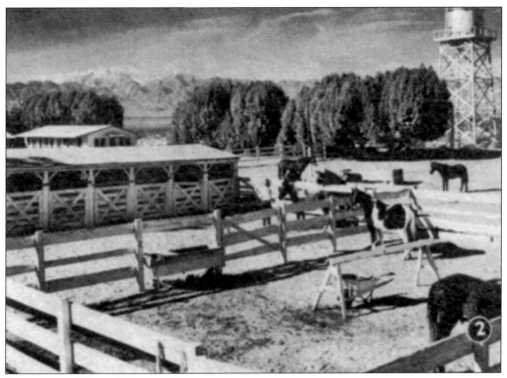

STABLES AND WATER TANK. Extensive stables and paddocks for horses show one of the alluring aspects of the dude ranch. The ranch advertised, "At B-Bar-H you'll trade a Cad or a Jag for a nag," and it was not kidding. Note the water tank in the upper right. Naturally warm mineral water was another enticement for city folk.

A PERFECT VACATION. An advertisement outlines a special offer to visit the dude ranch. "Here Is Romance, Steeped in the Legends of the Old West, A Place of Modern, Luxurious Living" is an alluring invitation to visit this desert oasis. For the special few, pick up at the Palm Springs Airport is an option.

1950s Transportation. Shown is a 1946 coaster used at the bar. Also pictured is a partial view of the station wagon used to pick up guests from the train station at Garnet or Palm Springs Airport just 10 miles away.

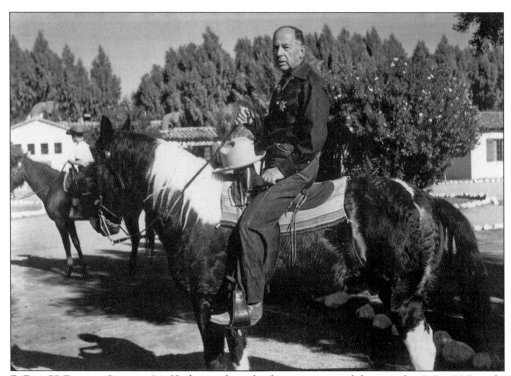

B-Bar-H Ranch Owner. Jay Kasler, on horseback, was owner of the popular B-Bar-H Ranch. His grandson Richard is in the background on the left. Kasler was also owner of the Free Sewing Machine Company, second only to the Singer Company. During World War II, his company became the largest producer of ammunition in the United States. After the war, he founded City National Bank. (Courtesy of Richard Roger.)

GOOD HORSEMAN. This 1946 picture shows the already proficient rider Richard Roger. Richard continued riding as an adult and participated in trail rides throughout his life—even though he had to take time off from his profession as a cardiologist at Eisenhower Medical Center to do it.

T CROSS K RANCH. Frank Delong operated a cattle ranch in Mission Springs Canyon from the early homesteading days. After running cattle was no longer an option, the ranch took on a new identity and became a guest ranch.

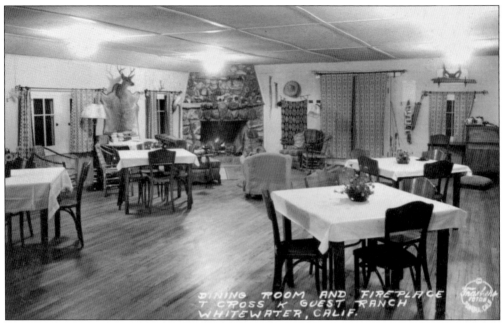

T Cross K Dining Room. The fireplace and dining room of the T Cross K Ranch no longer exist, but this picture shows how inviting they must have been. (Courtesy of Frasher Fotos Collection.)

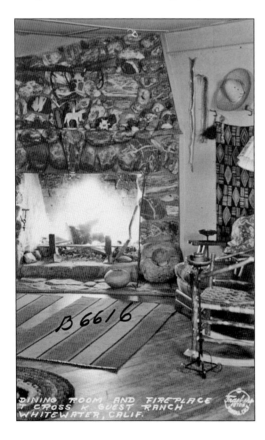

Dining Room Fireplace. A cozy fireplace added to the ambiance of the ranch's dining room. (Courtesy of Frasher Fotos Collection.)

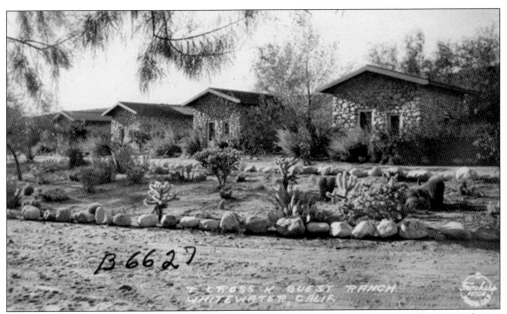

T Cross K Guest Ranch. These rock buildings would have been cool in the summer and cozy in the winter. Desert landscaping of cactus and rocks is an attractive addition. (Courtesy of Frasher Fotos Collection.)

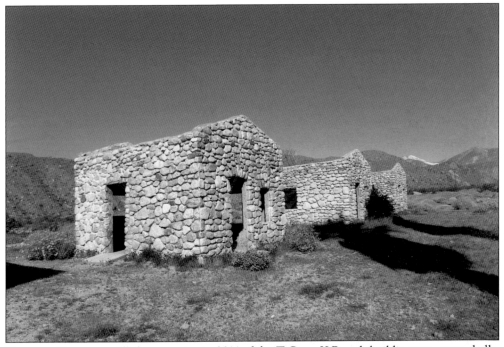

Derelict Remains. All that remains in 2014 of the T Cross K Ranch buildings are stone shells, which will stand for years more if not vandalized. Wildflowers in bloom complete the picture, and shadows of two tall palm trees edge across the picture. In the far distance, a small white slash is the snow-covered tip of Mount San Gorgonio.

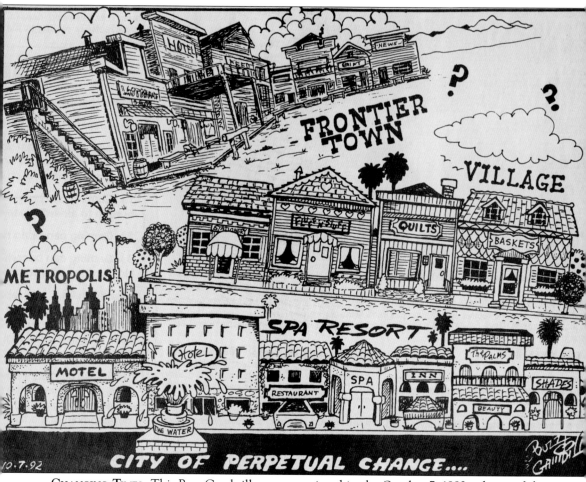

CHANGING TIMES. This Buzz Gambrill cartoon, printed in the October 7, 1992, edition of the *Desert Sentinel* newspaper, portrays changes a city may go through over time. Frontier Town in the upper left is prominent as a first stage and reminds one of the dude ranch era, when Desert Hot Springs was in its early formative stages.

Seven

SPA CITY

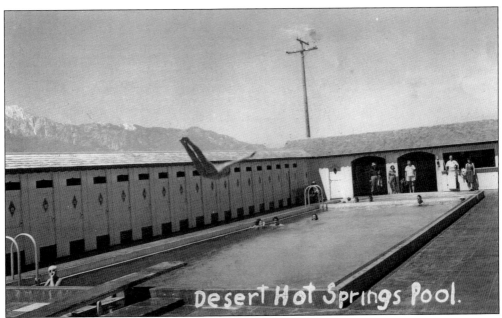

SPA CITY. L.W. Coffee pioneered the development of Desert Hot Springs and opened the historical Coffee's Bathhouse, where this young woman is shown performing a perfect swan dive. It was the beginning of an unprecedented, remarkable time during the city's history. When over 200 spas were in operation, the city became the Spa Capital of the World.

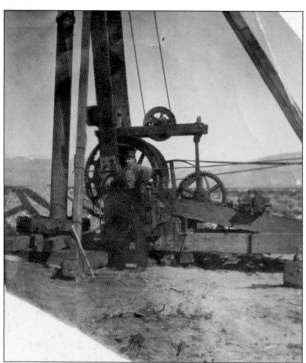

EARLIEST KNOWN WELLS.
Cabot Yerxa is credited with the discovery of the hot mineral water in 1914. Old Man McKinney, another homesteader, shown in the picture, dug his well near the intersection of what would become Pierson Boulevard and Indian Canyon Avenue. McKinney came to the area after serving with Teddy Roosevelt's Rough Riders in the Spanish-American War. (Courtesy of Brian Edwards.)

"TWO BUNCHES OF PALMS."
This native palm oasis was photographed in 1937. It was an early Native American watering hole marked on an official survey map drawn by the US Army Camel Corps of 1907. It ultimately became the location of the elite Two Bunch Palms Resort and Spa.

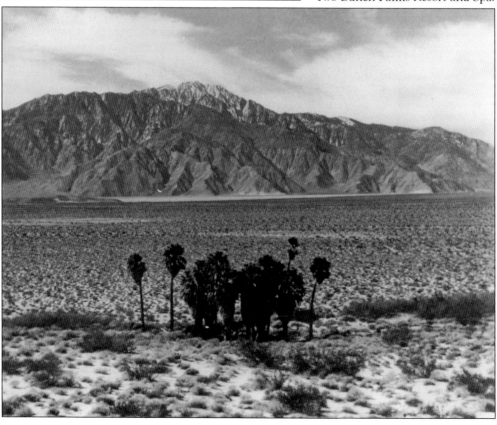

TWO BUNCH PALMS SPA EXPERIENCE. Highlights at this recently modernized, naturally hot mineral water resort include exotic treatments such as Shiatsu, Trager, Jin Shin Do, Swedish massage, and aromatherapy. Mud baths and body wraps take place in the "clay cabana." Guests may follow up with romantic, health-supportive dining, while enjoying a spectacular view of the San Jacinto Mountains. (Courtesy of Baerwald Photograph.)

GUEST ROOMS, SUITES, AND BUNGALOWS. Affectionately called "Two Bunch," this spa is surrounded with intrigue, mystery, and legends, including the stone house Al Capone is said to have built and occupied. The names of guests are kept private, but a few of the known visitors include Ozzy Osborne, Robert Altman, Douglas Fairbanks, Charlie Chaplin, and the Rolling Stones. (Courtesy of Baerwald Photograph.)

THE RADIOACTIVE RESORT. The Uranium Cave Motel incorporated the health benefits of mineral water and the radiation cure-all health craze of the 1950s. At that time, the *American Journal of Clinical Medicine* claimed uranium prevented insanity and retarded old age. In 1956, cave builder Darrell Gibson imported gold-glowing rock slabs from Idaho, Montana, and Barstow, California. He used his Geiger counter to sort out the hottest pieces, which he then cemented to the cave walls. Directly over the cave sat the Golden Lantern Trailer Lodge. The name Golden Lantern was derived from the radiation flow of the rocks and a burro named Lantern, who is buried out back. Stories continue that mobsters hid out in the obscure cave.

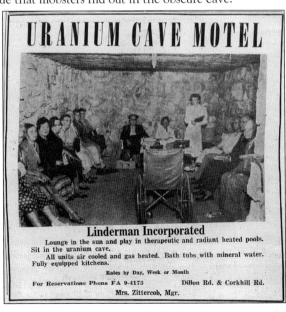

HEALTH-RELATED SPA NAMES. The Swiss Health Resort, shown above, focused on relaxation, peace, and harmony to relieve stress, increase energy and balance, and strengthen the immune system. We Care Health Center, pictured at right, was all about nutritional weight balance, adapting vegetarian diets, eliminating toxins, and exercise. Other spa-tel names emphasizing health were Desert Whole Health, Fountain of Health, Healing Waters, Hope Springs, and Living Waters.

WATER-THEMED SPA NAMES. Caliente Springs, Cactus Springs, and Emerald Springs used water-related names for their spas. Miracle Manor focused on reflexology, massage, and the natural wonders of water. It is shown above with the vintage sign. Motel names after the war were bold and original, often dictated by the regional culture.

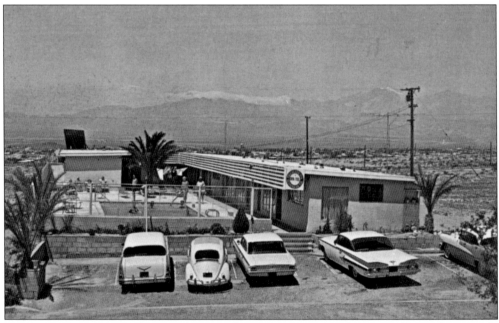

VACATION BY CAR. These automobiles parked at the Mona Lisa replaced family travel previously taken by train. They also remind people of the old days and nostalgic advertising slogans: "See the USA in your Chevrolet" and "What a thrill to take the wheel of a Rocket Oldsmobile."

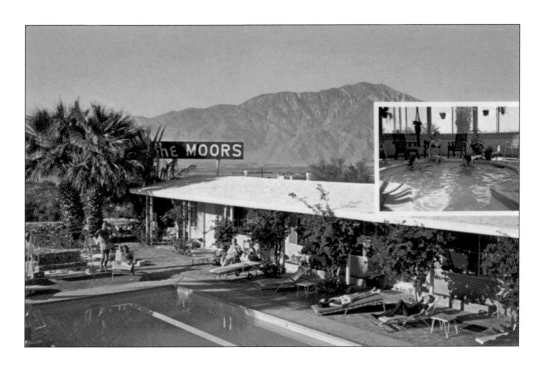

TRADITIONAL SPA-TEL SIGNS. The Moors postcard pictured above, with the catchphrase "A Home Away from Home," was published locally at D.H.S. Printing. Keer's postcard, pictured below, promoted hydrojets in its pools and was printed at Baerwald Photograph, also local. During the 1940s and 1950s, many local spa-tels simply used the owner's last name, like Bertram's, McLaughlin's, Mohler's, and J.D. Holmes.

CASUAL MOTEL SIGNS. El Gee Gee Stationers in Desert Hot Springs printed postcards for Míchal's, above, and Mary Ann Manor, below. Other first-name spa-tels were David's Spa and Lorane Manor Motor Hotel. They promoted a restful, relaxing atmosphere and reasonable rates.

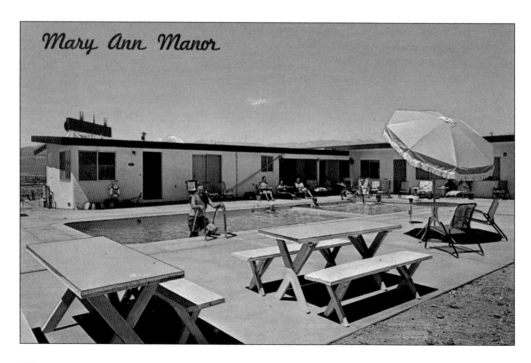

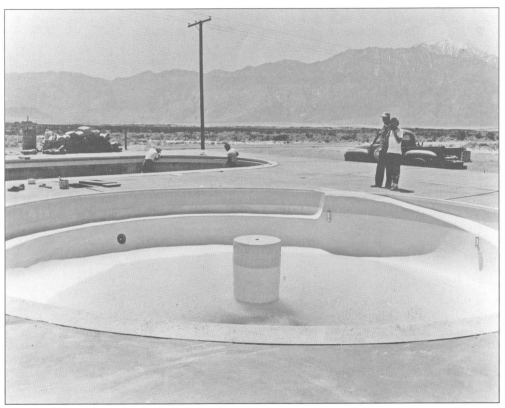

WATER TEMPERATURE. Pictured above are Dr. J.D. Holmes and his wife, Rose, admiring the nearly completed pool that he designed with a unique ramp to allow visitors with disabilities to enter. Now named Oasis Hot Springs, it had a well with a water temperature of 208 degrees, making it the hottest well in the desert. Another county resort, Sam's Family Spa, pictured at right, with wellheads at 105 to 140 degrees, used the clever slogan "We'll get you in hot water." Sam's decorative windmill is a reminder of the old wells used by mom-and-pop guest cottages. Ranging in temperature from 114 to 180 degrees, these wells were from 35 to 300 feet deep. The city of Desert Hot Springs is mapped with three distinct spa zones, and the county hot water zone could be considered a fourth.

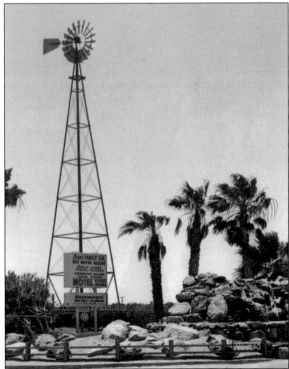

DESERT PALMS SPA MOTEL

67485 Hacienda Dr.
Desert Hot Springs, CA 92240
(619) 329-4443

- **6 Pools — Health Spa**
- **168°F Natural Hot Mineral Water**
- **Large Swimming Pool**

Analysis of Water	PPM		
Silica (SiO₂)	21.5	Sulphate (So₄)	493.6
Calcium (Ca)	45.1	Chloride (Cl)	120.5
Magnesium (Mg)	5.1	Bicarbonate (HCO₃)	129.0
Fluoride (F)	5.3	Alkalinity (pH)	8.3
Sodium (Na)	268.6	Temperature	168°F

- **110 miles east of L.A. and 12 miles north of Palm Springs**

WATER ANALYSIS. The Desert Palms Spa Motel includes an analysis of the water chemicals on the back of its postcard, at left. The health benefits emphasized were increased blood flow, cell regeneration, and the calming effect of the essential minerals. The chamber of commerce 1989 brochure, shown below, highlighted the minerals with the catchphrase "Forget Your Troubles in Nature's Bubbles." Emphasis to "Feel the Power of Nature" resulted from the city's award-winning cold drinking water and the benefits of soaking in the hot mineral water.

Dr. Broue, an Australian Chemist and Metallurgist, has spent many years traveling the world to analyse curative waters and makes this statement about the water in Desert Hot Springs.

"From the analysis of these waters, I have not found the like of them in any country I have explored. It is a pronounced curative agency, as is the air. It could be bottled and shipped everywhere."

To this point, however, it is not shipped out -- the way to enjoy the fabulous waters of Desert Hot Springs is to come and experience them in the atmosphere of clear air and sparkling mountain vistas.

NATURAL HOT WATER		WATER DISTRICT	
Silica	21.5	Boron (B)	.08
Iron Oxide	Trace	Potassium	11
Calcium (Ca)	45.1	Calcium (Ca)	56
Aluminum Oxide	Trace	Nitrate (NO3)	4
Magnesium (Mg)	5.1	Magnesium (Mg)	10
Sodium (Na)	268.6	Sodium (Na)	56
Sulfate (SO4)	493.6	Sulfate (SO4)	118
Chloride (Cl)	120.5	Chloride (Cl)	20
Bicarbonate (HCO3)	129.0	Bicarbonate (HCO3)	189
Flouride (F)	5.3	Flouride (F)	.7
Hydrogen-Ion Activity (pH)	8.3	Hydrogen-Ion Activity (pH)	7.8
Conductivity	388	Conductivity	630

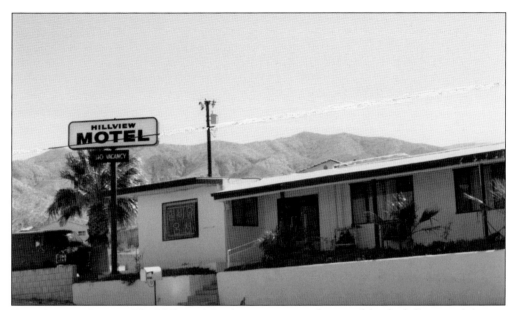

TIME AFFECTS DESIGN. The Hillview Motel was appropriately named for the hills around the city and beautiful mountain views. It was an example of graphic design use of all capital letters and emphasis on the word "motel." Symmetrical graphics were considered more elegant because tall thin letters were more difficult to read.

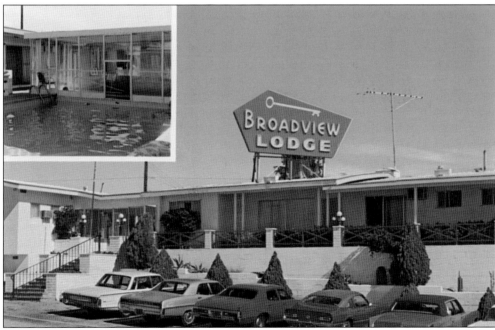

SCRIPT AND ICON SIGNS. The Broadview Lodge used a welcome key symbol and sign shape that followed the current vogue. It may have suggested adventure to travelers looking for lodging and who appreciated the convenient parking.

SPANISH CULTURE–THEMED SIGNS. La Fiesta, Casa Bienvenido, Casa Del Sol, and El Reposo were some of the spa names culled from the Spanish language. California is greatly influenced by the rich cultures of Mexico and South America. Linda Vista Lodge's newspaper notice provided additional information beyond its name and listed its many amenities and giving the temperature and mineral analysis of its well water. South of the Border, the award-winning Mexican restaurant, appealed to local residents and spa vacationers for over 20 years. As a young man, owner and host Fernando Guerrero, pictured below, was a matador in Ecuador, Spain, and Mexico.

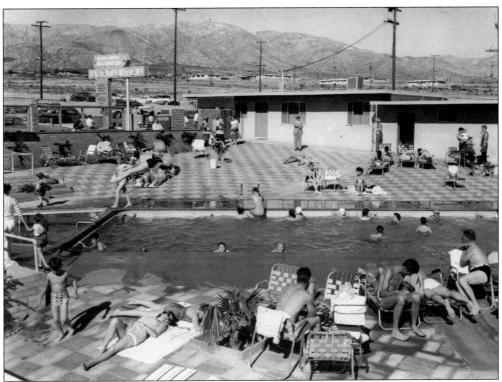

OLD CALIFORNIA–STYLE HACIENDAS. The Hacienda Riviera Spa, pictured above, was known as the "Health Center of the Desert" and was also popularly called "Play Spot of the Desert." Its covered patio, glass enclosures to maintain the view, private cabanas, diving board, and play area appealed to all ages. Hacienda Hot Springs Inn and Spa, pictured below, once the Royal Palms Inn, has been transformed into a lush oasis. It offers specialized saunas and vino therapy as well as bringing back traditional croquet and badminton. It hosted the historical society's first "Soup Supper" fundraiser in 2006 with a lecture and display of the owner's collection of Desert Hot Springs postcards. (Above, courtesy of *Desert Sentinel*.)

12885 ELISEO ROAD DESERT HOT SPRINGS CA 92240 TEL. (760)251-2885
HACIENDAHOTSPRINGS.COM

PROMINENT MOTEL SIGNS. When highways went straight through towns, it was easy for tired travelers to find a place to stay. When the interstate highway system bypassed towns, large hotel chains built new lodgings beside the new road, and many small motels went out of business. Taller signs, similar to Dos Palmas' "motel" sign, replaced the old 10-foot-tall signs. The new signs could reach a height of 80 feet in order for them to be seen from a distance.

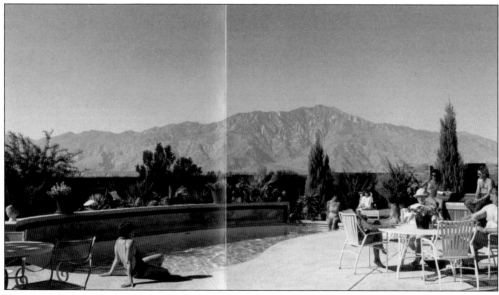

RETURN VISITORS. Lido Palms, seen above, had a flashing neon sign to welcome travelers at night. Vacationers often had favorite places to stay each year and shared their discoveries with family and friends while soaking in hot mineral water and relaxing in the warm desert sun.

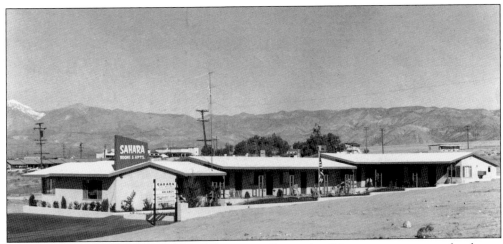

Spa Welcome. The welcome sign and American flag at the Sahara greet guests to the desert. Leaving the endless sandscape around them, guests entered wall-to-wall carpeted rooms with foam rubber upholstered furniture, washable chenille, Formica sofa arms, and twin beds. It was like a familiar scene from *I Love Lucy* in the 1950s.

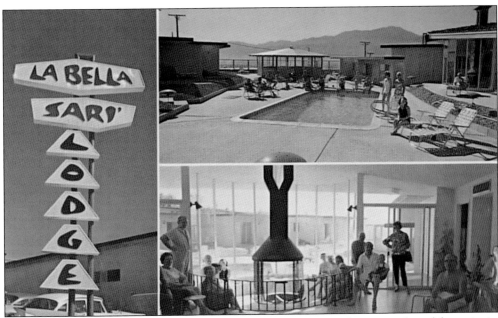

Extravagant Spa Sign. La Bella Sari's bold icon best conveyed a sense of confidence in its facility. The italicized graphics were created in an effort to draw attention to drivers across the open roads.

BEAUTIFICATION ACT OF 1965. Laws intended to prevent billboards in scenic rural areas did not apply to private property owners. Many old signs disappeared, so those that remain are valued for the graphic designs of the era. The tall Desert Hot Springs Spa sign, at left, continues as a landmark, although now, it is surrounded by neighboring homes and businesses. Next door is the Miracle Springs Resort and Spa. It has eight pools around a courtyard, conference space, 110 rooms, and banquet facilities as well as fine dining.

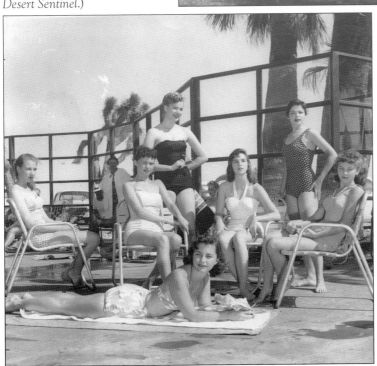

SUNBATHING MODELS.
Soaking up the sun before plunging into the hot mineral water, Diane Reed, left, and Marlene Bliss are having a poolside chat at the Desert Hot Springs Spa, shown at right. The unidentified swimsuit models at Desert Highlands, pictured below, are posing for a Desert Hot Springs postcard and newspaper. (Both, courtesy of *Desert Sentinel*.)

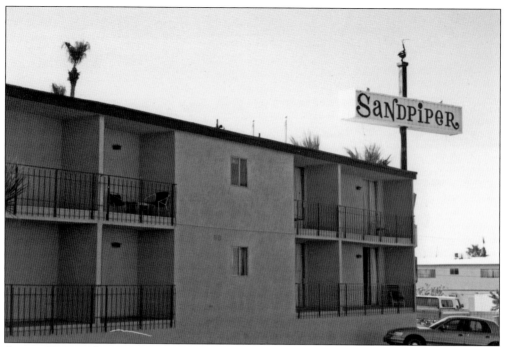

SPA-TEL BIRDS. The Sandpiper sign for a desert motel may not seem appropriate, pictured above, but actually, sandpipers do migrate across the Coachella Valley. A more common desert bird is the "snowbird," which flocks to the desert for the winter. The population almost doubles as Canadians and residents from other states rent or buy a second home to enjoy the desert's mild winter weather.

MOBILE HOME PARKS. To accommodate winter visitors, 500 mobile homes were situated at Desert Crest. Desert Crest was the first community in the area to have its own golf course. Regular events are golf tournaments and shuffleboard competitions at the largest indoor court in the valley. Guests can also enjoy bicycling, jogging, and dog walking. Like similar parks, other activities available are arts and crafts, Bingo, pool exercise, special breakfasts, holiday feasts, and entertainment.

EUROPEAN-STYLE RESORT. Formerly named Kismet Lodge, Living Waters Spa has been featured in the *New York Times* and *Washington Post* as one of the top 10 clothing optional resorts in the world. It offers individual and couples massage for those who dare to bare.

HOLISTIC RETREAT FOR CELEBRITIES. We Care Spa, another Hollywood getaway, is known for the Zen philosophy of rest, relaxation, and renewal leading to mental, spiritual, and physical healing. The local forerunner of getaways appealing to celebrities was the B-Bar-H Ranch, which was popular from the 1930s through the 1950s.

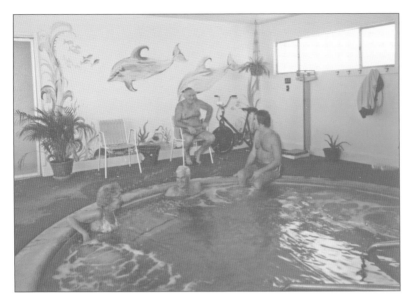

SPA MURALS. Desert Holiday's mural of playing dolphins is on the wall of the indoor Jacuzzi room. Another spa, the family-operated Sunset Inn was known for its magnificent 1,400-square-foot desert scene painted on the pavilion wall.

WATER ESCAPE. A spa visit for many people was to gain relief from a home located in a colder climate. Buzz Gambill draws upon that concept in his cartoon by showing what winter is like in the desert. Why shovel snow, if one can be soaking in hot mineral water and the warmth of the sun?

114

Eight

MAGIC OF THE DESERT

GEORGE GAMBILL AT WORK. Born and raised in Oklahoma, George "Buzz" Gambill was an editorial cartoonist. His characters reflected a simple way of life. He illustrated for over 40 years in magazines, local newspapers, and for individual clients. Buzz spent 18 of those years cartooning and illustrating for the former *Desert Sentinel*.

THE VALLEY BREEZE. When the *Desert Sentinel* was bought, the town was without a newspaper. With little experience in newspaper publishing, Buzz Gambill purchased the *Valley Breeze*, a four-page political flyer. He expanded it into a 24-page 7,000-circulation tabloid. With a readership of 20,000, it offered local news, entertainment, and full color.

THE LAST RESORT. While working for the *Desert Sentinel*, Buzz introduced a cartoon strip, "The Last Resort." The strip reflected upbeat commentary on life in Desert Hot Springs via two middle-aged citizens with children, grandchildren, and friends. While in the Navy, he created a strip called "Salty, the Seaman." It appeared in the base newspaper, the *Pearl Harbor Times*, and the famous *Stars and Stripes*, a military publication.

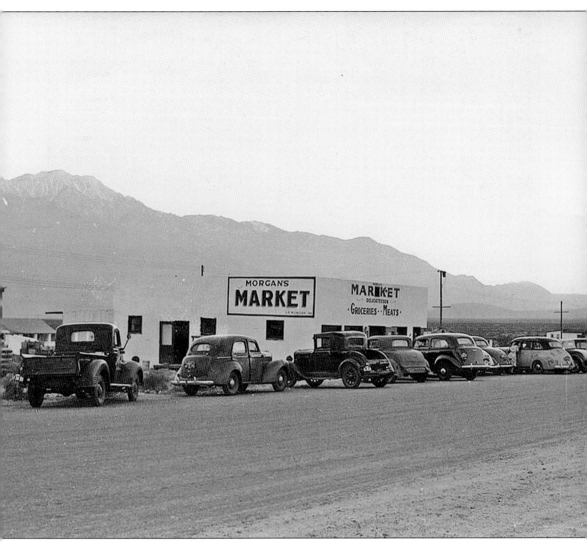

EARLY DAYS. When Leslie and Ferne Morgan arrived in Desert Hot Springs in 1944, there were no paved streets and few houses. Rattlesnakes were in abundance. Leslie Morgan, an electrical contractor from Los Angeles, came to the desert to escape the traffic of the city. He opened the first grocery store with refrigeration. With his two sons, he started a construction company. They built eight motels, two churches, and many houses. Leslie Morgan helped establish Angel View Crippled Children's Foundation, the first fire department, the library, and a number of other city institutions.

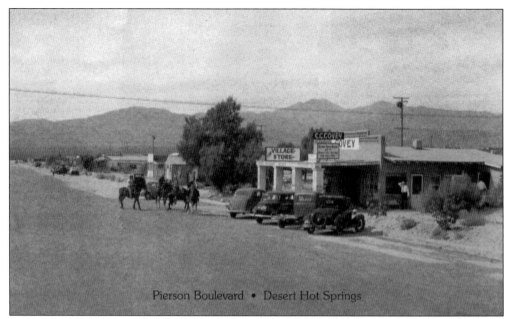

Pierson Boulevard • Desert Hot Springs

HAIDET'S HARDWARE. This hardware store is the oldest family-run business in Desert Hot Springs. John Haidet ran the commissary at the Army air base in Palm Springs until it closed in 1945. Suffering from asthma, the dry, clean desert air gave him relief. He opened his hardware store, and today, his son is carrying on the tradition.

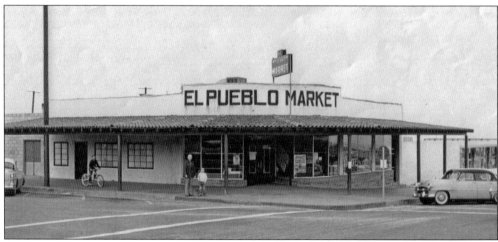

HORTON'S MARKET. During his high school days, Allen Horton spent many hours working for a local market. After military service, he visited Desert Hot Springs and fell in love with the town. With his friend Paul Price, he opened El Pueblo Market at Palm Drive and Cahuilla Avenue in 1946. In 1957, Allen bought out Paul's share, moved the market to Palm Drive and Pierson Boulevard, and renamed it Horton's Market, doubling its size. In 1974, Allen Horton gave up the operation.

KINGDOM OF THE DOLLS. Betty Hamilton had a hobby of making dolls and scenery out of anything available, and it soon became an occupation. The Kingdom of the Dolls had amazing miniature replicas of villages, castles, temples, places, and street scenes as they actually existed through the ages. Betty spent years researching the replicas she made. Numerous newspaper and magazine articles were written about the Kingdom of the Dolls.

THE FIREBALLS. The Desert Hot Springs softball team, the Fireballs, played in Wardman Park and provided great summer fun for the entire family. Pictured are, from left to right as identified on the back of the photograph, (first row) batboy Frances Markley; (second row) Frank Guatiello, Jack Morey, unidentified, Chad Cornelios, and Gene Farmer; (third row) Coon Mooney, Phillip Forrestberg, unidentified, George Ellis, unidentified, Woody, and Joe Morey.

CENTENARIAN. In December 1953, Mike Swan celebrated his 100th birthday. When he was younger, riding his bicycle was not an easy task considering many of the roads in town were not paved. Once, when he had a fire in his house and could not wait for the fire department, he turned on both faucets in his sink, stuffed a cloth in the drain, and then used a kettle as he dashed back and forth to put out the fire.

WIND, WIND, WIND. This was always a problem in the desert communities. With so few buildings in the early days, blowing sand became an overwhelming problem. The city council thought building windbreaks was one of the answers. Bob "Acres" Wertz did not want to wait. He went out and planted 1,500 feet of tamarisk trees on 25 acres. Bob also decided the city needed more flowers, so he went up in a private plane and scattered wildflowers seeds all over the town.

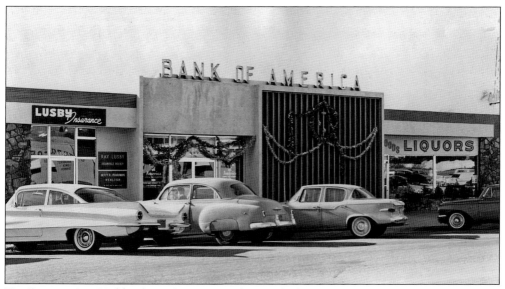

THE LATE 1950s. Unlike the early pioneers, the people that came to the desert in the 1950s had some paved streets and electricity but not much else. Many had left the comforts of the city to pursue new dreams or just visit. Development was flourishing with new houses, restaurants, and other merchant businesses. The Bank of America, built in 1957, was the first bank.

CAPRI RESTAURANT. In 1976, John Santucci came to the desert because of his health, which was in decline due to a war injury. A butcher by trade, he was involved in many operations of the restaurant business. He acquired the Capri restaurant; steaks and Italian food were his specialty. Soon, his entire family was working for him. A landmark for over 35 years, the Capri restaurant is now at the Miracle Springs Resort and Spa.

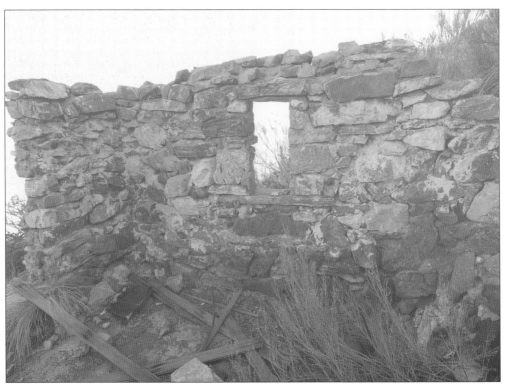

CHUCKAWALLA BILL. William Anthony Simmons was born in Pennsylvania in August 1875. His early adult life was spent in the military. A transient lifestyle led him to living in caves along the Colorado River and in the Nevada desert. Many years were unaccounted for, but in 1930, he lived in a stone cabin in Long Canyon, a few miles from Desert Hot Springs. One day a priest visited, and Bill fed him a chuckawalla lizard passed off as fish. The incident led to his being called "Chuckawalla Bill," a name he inscribed above his fireplace in 1934. He died at 81 in 1950.

WITH LOVE. Pet Haven is the only pet cemetery in the Coachella Valley. Over the entrance on Dillon Road hangs an old whitewashed hand-painted sign in black letters with the simple words Pet Cemetery. Pres. Gerald Ford's golden retriever Liberty and Liberace's five dogs Lady Di, Ciao, GiGi, Prego, and Bonaparte are buried at the cemetery.

POST OFFICE. The first official post office opened on September 5, 1944, in the office of developer L.W. Coffee, on the corner of Pierson Boulevard and Palm Drive. Between 1945 and 1950, the post office advanced from third class to second class. At one time, Morgan's market was renovated to accommodate the expanding post office. In 1955, a new post office was built. Part of the service a post office gives is largely determined by the postal receipts. Local residents were urged to buy stamps, cards, and stamped envelopes. On April 21, 1958, home delivery started serving people along Dillon Road.

ROTARY CLUB. In 1946, Samuel Dudlext, past president of the Downey, California, Rotary Club, bought the drugstore building. At the same time, Frank Kibbey from Laguna Beach bought the Idle Hour Café. He was the past president of the Lions Club. Both men felt the need for a service club. The Palm Springs Rotary sponsored the new Desert Hot Springs Rotary Club. Charter night was held on December 5, 1947, on the patio of the Idle Hour Café. (Courtesy of Desert Hot Springs Rotary Club.)

A Helping Hand. Cole Eyraud, president of Hospice of the Desert, accepts a check from board president of Hands of the Desert Mary Keefe. In 1975, a group of dedicated women formed a nonprofit organization, Hands of the Desert, to help individuals in need, as well as other charitable and civic service groups. They operated a thrift store on Pierson Boulevard. The group dissolved in 2007, and over $100,000 was distributed to 16 local and other Coachella Valley charities.

THE DRUGSTORE. In 1969, John Furbee, a pharmacist, bought the only drugstore in town from Johnny O'Conner. The name "Drug Store" was placed in block letters on the building. When John answered the phone, he just said, "Drug store." He sold it in 1977. The independent pharmacy lasted a few more years, and eventually, a major chain took over.

JOHN LAUTNER. One of America's most significant contemporary architects, John Lautner apprenticed under Frank Lloyd Wright from1933 to 1939. In 1947, Hollywood producer Lucien Hubbard commissioned him to build a planned community in Desert Hot Springs. Only a four-unit prototype was built before the project was halted. The building fell into disrepair. Purchased in 2000 by artist Steve Lowe, the four units were renovated and reopened as the Desert Hot Springs Motel. When Steve died in 2005, the doors closed again. In 2011, two designers, Tracy Beckman and Ryan Trowbridge, bought the motel, and in 2014, the Lautner Motel officially opened, and it now showcases the genius of John Lautner.

THE VISION. Through Buzz Gambill's art, the reader can see his vision for a developing city. New projects were being planned, and the existing ones were being expanded or renovated.